IMAGES
of America

STATEN ISLAND'S
GREEK COMMUNITY

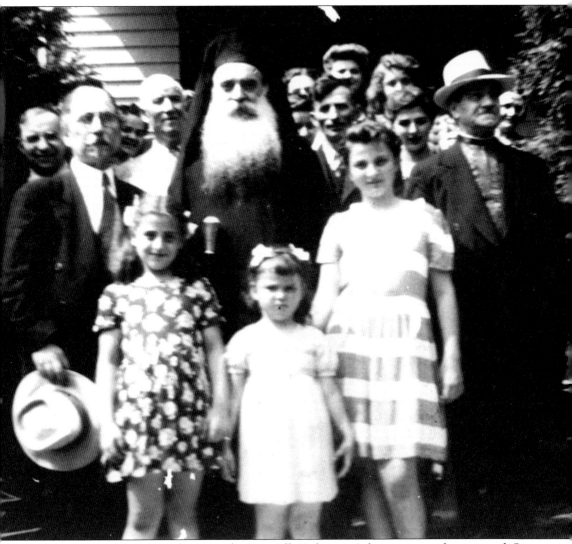

Before he was elected patriarch, His All Holiness Athenagoras, often visited Staten Island. People would stare in amazement as (then) Archbishop Athenagoras took the ferry from Manhattan to Staten Island. A tall man, he seemed enormous with his kalimafki (the hat which signifies that he is an Archimandrite). He came to conduct religious services and spend the day with the farmers. He especially enjoyed a meal of leeks and rice. This photograph was taken in the early 1940s. Pictured with him are from left to right: (first row) Sophie Skunakis, Kiki Exarchos, and Georgia Exarchos; (second row) unidentified, Rev. Dr. Dimitrios Callimachos, Lambros Hatzis, unidentified, and Dimos Exarchos. When he was elected Patriarch, Pres. Truman's plane took him to Constantinople. (Courtesy Holy Trinity-St. Nicholas Greek Orthodox Church.)

IMAGES
of America

STATEN ISLAND'S
GREEK COMMUNITY

Christine Victoria Charitis

Published by Arcadia Publishing
Charleston SC, Chicago IL, Portsmouth NH, San Francisco CA

Printed in Great Britain

Library of Congress Catalog Card Number: 2005926080

For all general information contact Arcadia Publishing at:
Telephone 843-853-2070
Fax 843-853-0044
E-mail sales@arcadiapublishing.com
For customer service and orders:
Toll-Free 1-888-313-2665

Visit us on the Internet at http://www.arcadiapublishing.com

*To my two precious gifts from God. To Joanna (right) the only
"Native Staten Islander" in the family. She left a legacy of love, faith,
and determination and touched the hearts of all who knew her
(1972–1993). To Victoria (left) who brings love and joy to family
and friends. Her legacy will be revealed in the years to come (1987–).*

CONTENTS

FOREWORD

When someone speaks of "Greeks," immediately the mind goes to feta cheese, roasted lamb, resin wine, and breaking dishes while you dance. These are the worldly images of Greeks.

How do Greeks look at themselves, though? They see themselves as religious, family-oriented, hard working, patriotic, traditional, strong-willed, empathetic, "enjoying life" people; people who were willing to leave their homeland to provide a better life, not for themselves, but for their children and grandchildren.

This is exactly what those immigrants were thinking when they settled on this southern island borough of New York. They were not looking just at the present but what was to come for their families here in the New World.

The one thing which is prominent in the makeup of these Greeks is their dedication to their faith and their history. Faith, above all, the Eastern Orthodox faith, is the bedrock of who a Greek is, and the Greeks of Staten Island are very dedicated to their Orthodoxy. For these people, like all other immigrant Greeks in the United States, the most important thing that they could establish was a local church. They knew how to work hard, but without the church, they could not be re-charged to keep going on. They needed that place to spend their "day of rest;" to be blessed and to visit with their fellow Greeks. Greeks *had* to have their church, and they would make great sacrifices to have their spiritual enrichment.

Here on Staten Island, once the early settlers, who were mostly farmers and restaurateurs, were established, they provided the preservation of both their ethnic and religious heritage by establishing the Aristotle Society (ethnic) and later, the Holy Trinity-St. Nicholas Greek Orthodox Church (now 78 years old). With these two tools in their hands, they established themselves as good Americans.

The Greeks of Staten Island have established themselves in American and New York society. Education has always been paramount, for the Greeks and their descendants are among the most educated of all ethnic groups. Among them today we find doctors, nurses, lawyers, accountants, professionals (on all levels), educators, politicians, builders, businesspeople, restaurant owners, and one working farmer. The Greeks of Staten Island, as faithful Americans, have served in all branches of the military, during all military actions, some paid the ultimate sacrifice to defend freedom and democracy (a Greek gift to the founders of this country). They served when called upon, and they served proudly as Greeks and as Americans.

As you read and study this book, learn about the Greeks of Staten Island who came to this country, and this island, with a dream for their future and how they have achieved whatever they set as goals for themselves and for the Greek generations to come.

—Rev. Protopresbyter Nicholas P. Petropoulakos Proistamenos, pastor

INTRODUCTION

Now that you've arrived, step off the boat and see how
much Staten Island has waiting for you.
—"Welcome to Staten Island" Brochure

The history of Staten Island's Greek community resides in a single century—one hundred years—from the first decade of the 1900s to the present. Yes, there were a few people of Greek descent before 1900. Nicholas B. LaBau, whose maternal grandfather was born on the island of Scio, served as a New York State Senator, First District (Staten Island) in 1866 and 1867, before moving to Warren County. He was honored on Hellenic Pride Day, March 23, 1993 by the New York State Senate for his "forceful activities in furtherance of the cause of the Union during the Civil War Era." Aside from LaBau, no reference to prominent Greek-Americans in the 1800s could be found. Rather there were Greeks who immigrated to America in the late 1890s and early 1900s who became Americans, men whose names will not be brought before the New York State Senate: Anagnostis, Chrampanis, Exarchos, Itsines, Katsoris, Psomas, Skunakis, and Thanasoulis to name a few. Although these first Greek-Americans and their peers never achieved political prominence, their names are legend to the Greek community and to Staten Islanders who lived here and remember the "truck farms" and businesses those names came to represent in the first half of the 20th century.

Stapleton was named for William J. Staples. Rossville was named for Col. William E. Ross. St. George was named for George Law. Dongan Hills was named for the Dongan family. You won't find any towns named for Greeks in Staten Island; they came after the towns and streets were already named. Even though the towns did not bear their names, they did sort of take over the towns of New Springville and Bulls Head with their farms and their large families. Those who weren't farmers settled in Port Richmond, a town filled with businesses and shops.

There is no census data to show when Greek immigrants first came to Staten Island, but federal census data estimated that there were between 69 to 78 Greek born residents in New York City prior to 1891. Between 1890 and 1900, approximately 16,000 immigrants had arrived from Greece, with 1,300 Greeks residing in New York. By 1924, approximately 400,000 Greek immigrants had arrived in America, so we can surmise that a good number of them remained in the New York area.

Although it had become one of the five boroughs of New York City in 1898, this little island measuring only 13 miles long and 7.3 miles across at its widest point was isolated from its neighbors. At that time transportation to and from Staten Island was limited. The ferry from St. George to Manhattan began service on October 25, 1905. Ferries from Holland Hook to Elizabethport and Tottenville to Perth Amboy, among others, facilitated passage between points in New Jersey and Staten Island. In 1889, the Baltimore and Ohio Railroad opened a bridge over the Arthur Kill. It joined Holland

Hook to Elizabeth, New Jersey. On January 1, 1890, the first passenger train passed over the bridge.

Bridges constructed for automobile travel were the next step in the "deisolation" of Staten Island. The Outerbridge Crossing, connecting Tottenville with Perth Amboy, New Jersey, and the Goethals Bridge, connecting Holland Hook with Elizabeth, New Jersey, both opened on June 20, 1928. The Bayonne Bridge opened on November 15, 1931, connecting Port Richmond with Bayonne, New Jersey. The Verrazano-Narrows Bridge, connecting Fort Wadsworth with Fort Hamilton, Brooklyn, opened on November 21, 1964. Staten Island was now accessible to both of its neighbors. Big changes were in store for this sleepy borough.

The Greeks came to America out of economic need. Some came from small islands where there was little land available for their large families. They also came for the democratic freedom America offered. They possessed few skills and knew no English, but managed to find work in the cities. For many, the wish to earn money and return to Greece was not an achievable goal. They remained here. For the vast number of Greeks who settled in Staten Island, the goal was to bring their loved ones to America. This goal was achievable. Year by year, relative by relative, they brought their families to Staten Island. Drawn together by the common bonds of language, religion, and culture, Greeks tended to marry other Greeks. The result was the creation of a Greek village atmosphere here on Staten Island. As they created their Greek village, they also built a church, found their niche, and managed to keep their culture and language alive. They became Americans in every sense of the word, but retained their individuality in the melting pot we call New York City.

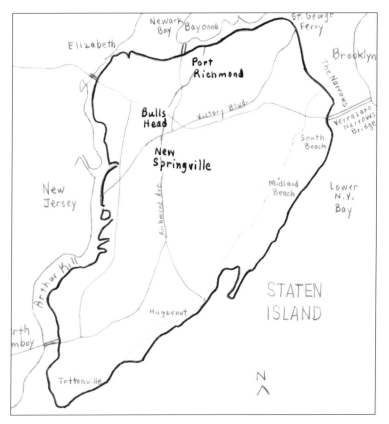

The bold print on this map of Staten Island shows the areas of greatest concentration of early Greek immigrants. The farms were in Bulls Head and New Springville; the businesses were in Port Richmond. The shoreline areas of Tottenville, Huguenot, Midland Beach, and South Beach were the draw for families who summered here and stayed in later years. The Verrazano-Narrows Bridge lured Brooklynites with the promise of easy travel.

One

COMING TO
STATEN ISLAND

*All of our people all over the country—except the pure blooded Indians—are immigrants or
descendants of immigrants, including those who came here on the Mayflower.*
—Franklin Delano Roosevelt's campaign speech in Boston, November 4, 1944

Greek people came to Staten Island in waves of time that mimicked the gentle waves
lapping at Staten Island's 35 miles of waterfront: 1900–1925, 1930–1955, 1960–present. In
the beginning of the 20th century, immigrants came from Greece for economic reasons.
The islands and towns were small and undeveloped, providing little income and inheritance
for the many sons and daughters of each family. America was the land of promise, so they
left their homeland in search of a better future. They endured the hardship of steerage
class passage on large ships, filled with others who shared their dream, to get to America.
They passed through Ellis Island, but didn't come directly to Staten Island. Some went to
Manhattan, Chicago, Pennsylvania, or Massachusetts first.

In general, Greek immigrants came to America without jobs or skills, so they
congregated in the cities that offered employment. They worked as bootblacks, dish
washers, flower sellers, peddlers, and factory workers. They became cooks and entered
the restaurant business. Eventually, they started their own shoeshine businesses, flower
shops, candy shops, and ice cream parlors and entered the mainstream of American
business. There is no specific information about the first jobs Staten Island Greeks had
other than the following references. Emanuel Katsoris came to America in 1901, went
to Chicago and learned to make ice cream from his godfather. Gus Thanasoulis worked
with relatives in a Manhattan florist shop. Basil Anagnostis and Anthony Chrampanis
worked in a cigar factory in Manhattan. It seems apparent that they entered the workforce
in the same way other Greek immigrants did. Those who left Manhattan either found
work on the farms in New Springville and Bulls Head (work they understood) or worked
in small businesses and ice cream parlors in Port Richmond. Eventually, they purchased
their own farms and businesses and brought their families from Greece to join them.
There was a distinct dichotomy between the two groups.

Although Greeks continued to arrive from Greece, the second wave of Greeks did
not come from Greece. They came to spend summers in the bucolic splendor that was
Staten Island. They rented bungalows in Tottenville, Huguenot, South Beach, and
Midland Beach and fell in love with Staten Island. They came from Manhattan and the
Bronx for the summers and remained. The Petrides family and the Stathis family were
two summer residents who became permanent residents.

The third wave of Greeks (mainly from Brooklyn) came because the Verrazano
Narrows Bridge opened, offering them easy access between Brooklyn, Staten Island,
and New Jersey. Houses and property were inexpensive in 1964. Land was plentiful and
available. This is not the case today, yet the Greeks (and others) keep coming.

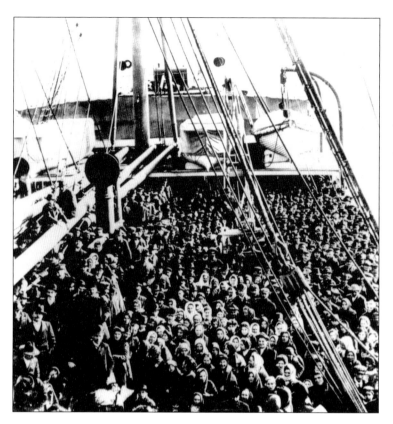

The steerage deck of the S.S. *Patricia* in New York Harbor is typical of immigrant travel to the United States in 1906. (Courtesy National Park Service, Statue of Liberty National Monument.)

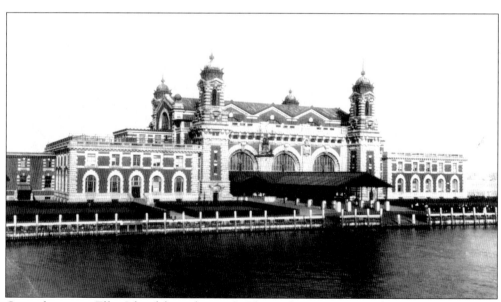

Over the years Ellis Island has changed. This is how it appeared to the early Greek immigrants. The steel arch built in 1903 was taken down in 1931. (Courtesy National Park Service, Statue of Liberty National Monument.)

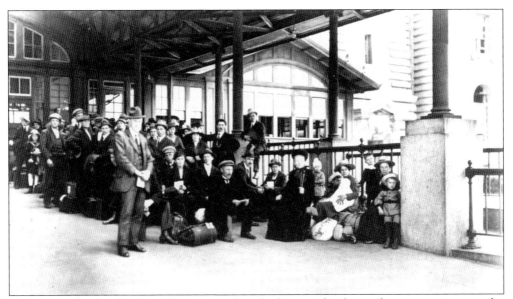

Barring medical or legal problems, it took only three to five hours for an immigrant to be processed and cleared. Imagine how Zacharoula Chrampanis felt as she waited two days for her bachelor brothers, Antonio and Peter, to come and get her. They had forgotten the date of her arrival; she was "fighting mad" when they finally came. (Courtesy National Park Service, Statue of Liberty Monument.)

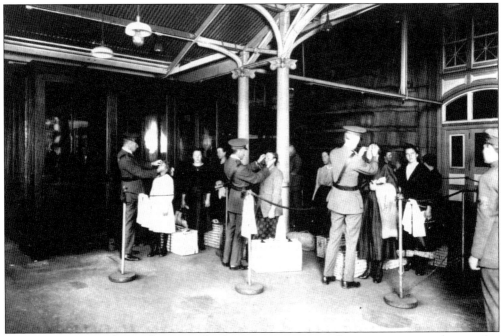

Eye examinations for trachoma and other contagious eye diseases were mandatory. An immigrant found to have a disease was set aside in Medical Detention Island 2 or 3 for medical treatment until cleared. If incurable, the immigrant was marked Medically Inadmissible to the United States, and sent back for deportation. (Courtesy National Park Service, Statue of Liberty Monument.)

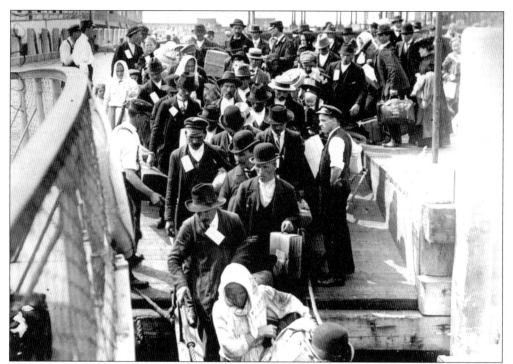

After obtaining medical and legal clearance, immigrants were ferried to New York City to start their new life. This image shows immigrants departing after completing inspections. They were given tags with their names as listed on the ship. For most, it was the first time they heard their name pronounced by Americans. (Courtesy State Historic Society of Wisconsin.)

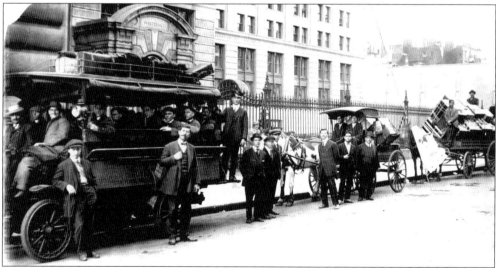

John Booras brought immigrant Greeks from the boats to Whitehall. He helped them settle in areas where there were jobs or people waiting for them. He put them on trains and paid the conductor $1 to take them to Chicago or other cities. They wore tags that included their name, destination, and the words, "Don't speak English." They would be claimed, hopefully, at the proper stop. (Courtesy James Kindos.)

Pictured in this undated photograph are Stella and John Skunakis in the yard of their home in Crete. Their sons, Nick and Stratis Skunakis, became farmers on Staten Island. (Courtesy Stella Vlastakis.)

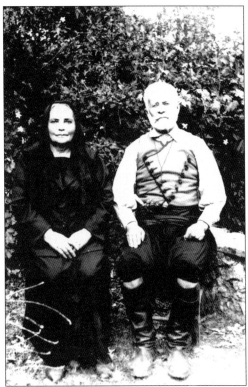

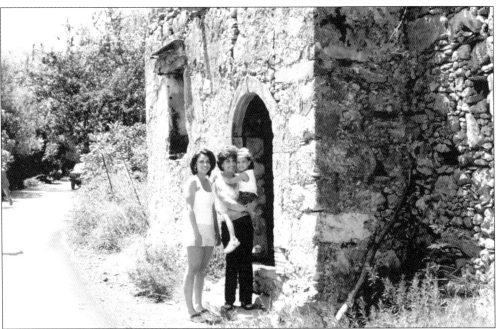

Descendants of Stella and John Skunakis visited Sirikari, Crete. The shell of the house Nick and Stratis grew up in is still there. While Stratis's daughter, Stella, visited with her daughter-in-law, Kaliope, and granddaughter, Stella, neighbors asked them to fix up the house and come to live there again. (Courtesy Stella Vlastakis.)

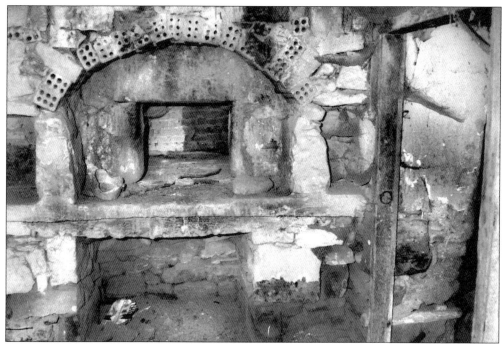

The Chrampanis family came from Karpasi on the island of Lemnos, Greece. Thomas Thanasoulis described the home of his mother, Stamatia (Chrampanis) Thanasoulis, as "having a dirt floor which was deeper at one end." This image shows the Chrampanis's oven. (Courtesy Thomas Thanasoulis.)

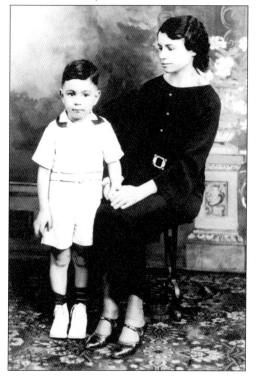

In 1920, Stella (Kakounis) Vozeolas, came to America from Sparta with her sister Jennie to find a husband. They left their large family of three brothers and four sisters, traveled steerage class, and passed through Ellis Island. In 1980, Ellis Island recorded their story. Once here, marriages were arranged for them. Stella is pictured with her son Spero. (Courtesy Stella Vozeolas.)

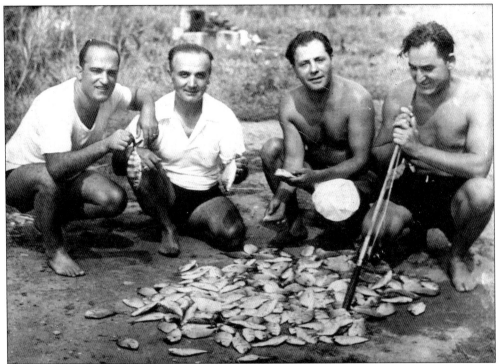

In the 1930s and 1940s, so many Greek families came from Manhattan and the Bronx to spend the summer on the beach in Tottenville that they used to call Loretto Street "Little Greece." From left to right, Chris Stathis, Panos Stathis, Enzo Benfonte, and a man known as Cretikos are shown with a fresh catch of porgies, which went straight from the beach to the pan. (Courtesy James Stathis.)

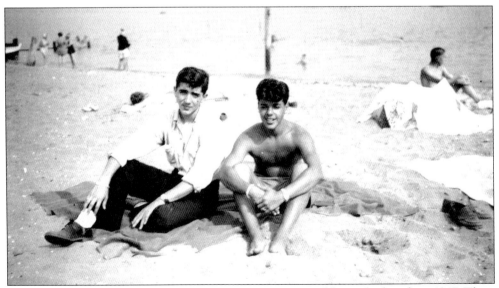

John Stathis and John Kartelias spent every moment possible on the beach in 1947. Their families had bungalows on Rockaway and Loretto Streets. Eventually, both married and raised their families on Staten Island. (Courtesy John Kartelias.)

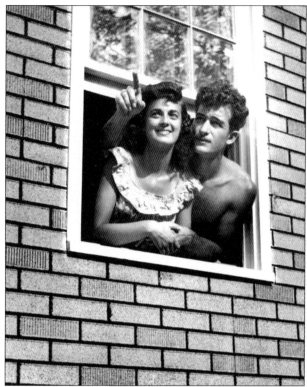

In 1956, George and Margaret Garis visited her parents' home on Loretto Street in Tottenville. The Jonas family had moved here from the Bronx in 1952. George is pointing to a house on Amboy Road where he and Margaret would soon move. George is known to many as "Mr. G," for his work with the Boy Scouts, while Margaret was known for her paintings and philanthropic work. (Courtesy George Garis.)

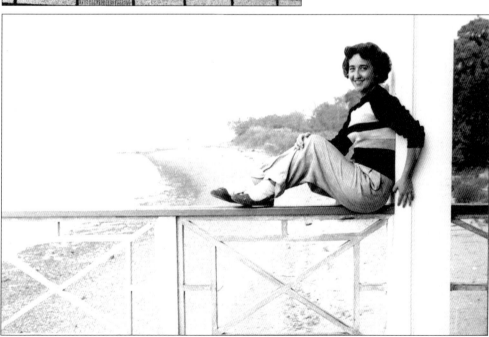

Georgia Jonas is sitting in the pavilion at "the Point," next to the Conference House in 1944. Every Saturday night Georgia, her family, and friends, would walk one and a half miles to the pavilion to listen to the free music provided by the Police Athletic League. (Courtesy James Stathis.)

Byron "the weasel" Karson (left) and John Stathis shared a laugh as they shopped along Yetman Avenue in Tottenville. Those were the days of paper bags. Also pictured here are Artie Kontovasilis and Philip "Beano" Karson. (Courtesy John Stathis.)

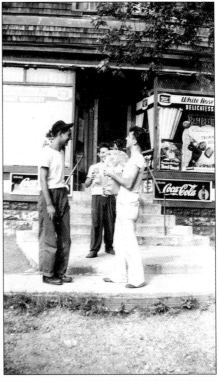

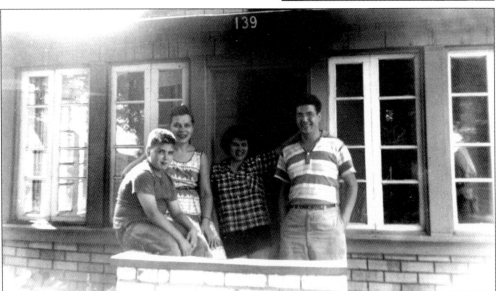

Midland Beach was another favorite summer spot for Greek families in the 1950s. John and Eftihia Kusas, of Manhattan, rented the bungalow at 139 Kiswick Street in Midland Beach before purchasing it in 1953. Relaxing in front of the bungalow, from left to right, are John George, Helen Koussandianas, Catherine George, and Gust George. Another family that spent summers in Midland Beach before moving there was the Petrides family. In fact, Michael and Gus Petrides became lifeguards there. The beach was so crowded you couldn't find room for your blanket. (Courtesy Catherine George.)

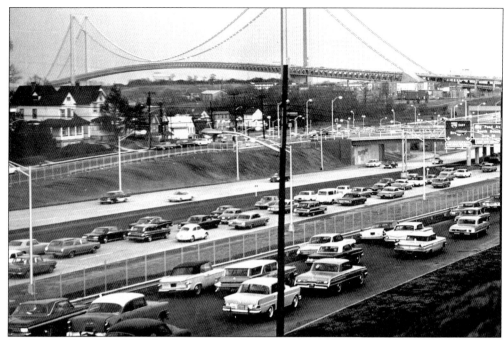

On November 21, 1964, the Verrazano-Narrows Bridge opened, linking Staten Island to the rest of the boroughs via Brooklyn. Staten Island was forever changed. It would no longer be a small town. The population exploded; it is now 460,000 and growing. The demand for new homes was, and still is, phenomenal. People continue to pour in from Brooklyn and other boroughs taxing the streets, the schools, the work, and the recreational areas. It impacted the Greek community too. A bigger church and community center needed to be built to fit the needs of an expanding congregation, and the farmers relinquished their farms. (Courtesy Staten Island Advance.)

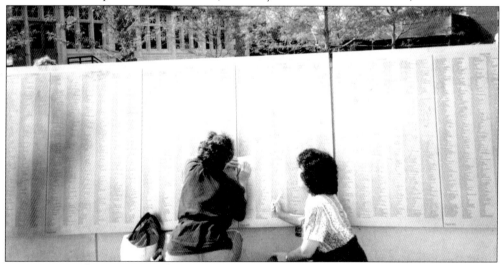

So many Greek immigrants have passed through Ellis Island. The "Wall" is a constant reminder of the courage and sacrifices our ancestors made to come to America. In this photograph, the author and her sister, Barbara Sarver, have discovered a family member's name and are taking a rubbing if it. (Courtesy Christine Charitis.)

Two

THE GREEK FARMERS OF STATEN ISLAND

It has been said that the soul of the island's agrarian community was Greek.
—Mike Azzaria, Memories, Staten Island Advance, November 1, 1998

Staten Island's agrarian community was Greek? To use a strictly American phrase, "so who knew?" An airport? A drive-in theatre? Large Greek farms? They were already history by 1971, a time when a lot of homes were being built. Only one farm, a small one at that, remained by the 1970s; the Chrampanis farm. A course at the College of Staten Island, the History of Staten Island with Professor Howard Weiner, challenged students to investigate some aspect of Staten Island's history. Investigating the Greeks of Staten Island unearthed an extensive history of Greek owned and leased farms that had once existed.

If, as the historians said, Greek immigrants went to the cities, how then, did many of them become farmers in Staten Island? Take a look at Staten Island during the time of the large influx of Greeks into America. In 1886, there were 364 farms on Staten Island. It was the second largest industry on the island, second only to fishing. Many of the farmers had other jobs and did farming to supplement their income. They sent their surplus to the markets or to the city. The farm work was done by manpower and horsepower. The farm hands were recent Italian or German immigrants who lived on or near the farms. These farms were probably similar to the farms in Greece, where manpower was the only power. Since the men were uneducated and unskilled, farming must have seemed an answer to their prayers, because hard, manual work reaped monetary rewards.

According to a history written by Dr. Nicholas Itsines, there were 76 Greek families living on Staten Island by 1930, and most were farmers. No one seems certain who the first Greek to come to Staten Island was, but many believe that it was Stelios Anagnostis. Through oral interviews and research for this book, the following list of farms and their locations emerged. In New Springville, on Richmond Avenue, farms were owned by the families of Chrampanis—Talumbos, Bakalis—Thanasoulis, and Baxivanis. A farm on Travis Avenue was owned by the families of Exarchos and Skunakis. In Bulls Head, on Merrill Avenue, farms were owned by Basil Anagnostis, Stelios Anagnostis, the Dorgas—Itsines—Pavalos family, the Katsaros family, and the Kostandelos family. On Lamberts Lane, farms were owned by the families of Kefalinos and Tsourekias. On Victory Boulevard, farms were owned or leased by the families of Paramithis and Psomas. The time frame for these farms was 1910–1970 with the bulk of them being sold before 1970.

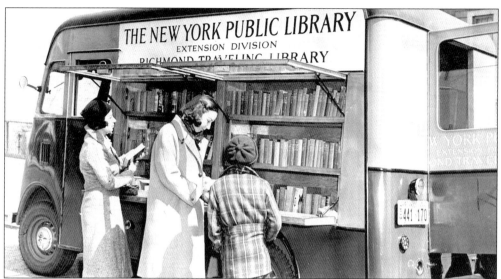

In the 1930s, librarians Elvira Cunningham and Marie Hartmann took a truckload of books called The New York Public Library Extension Division Richmond Traveling Library to areas that did not have library branches. Bulls Head and New Springville had so many Greek immigrants that the "bookmobile," as it was called by schoolchildren, brought along Greek books. (Courtesy Staten Island Advance.)

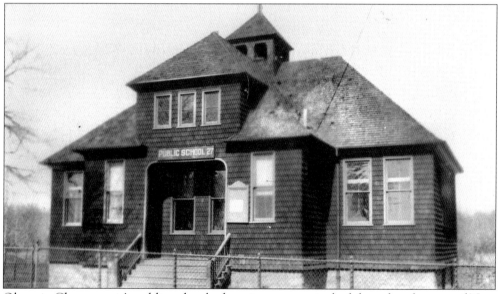

Olympia Chrampanis's public school education was typical of the other farmers of New Springville. They went to PS 27, built in 1880 (now demolished) for grades one, two, and three. They attended either PS 26 or PS 22 for grades four through eight, and completed their education at Port Richmond High School. Chrampanis describes PS 27 as a one-room schoolhouse. The teacher, Mrs. Boddinghaus, who taught all three grades, rang the bell to call the children in. There were six rows of desks. The students were seated by grade, 1A, 1B, 2A, 2B, 3A, and 3B. Students were promoted every six months, so they moved over one row every six months. Chrampanis recalls that the school had something impressive; a telephone. (Courtesy Staten Island Historical Society.)

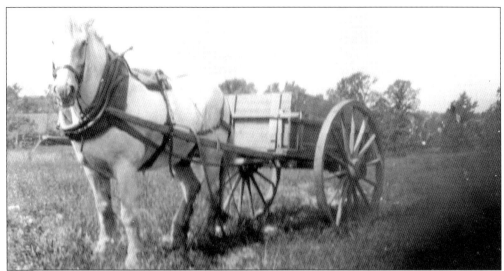

The Greek farmers did not have trucks until the 1930s. Before that they used horse drawn wagons much like this one. Some of their wagons had a unique feature, a double-door bottom. Manure was so important to good soil that some farmers spent the winters gathering manure from chicken coops. The head of the local Farmers Association, Herman Mohlenoff, ordered scows of manure for Staten Island. The farmers came and filled their wagons. To avoid unloading the manure by hand, they would pull a cross bar from under the wagon. This would open the double-door bottoms, and the manure would unload itself. (Courtesy Staten Island Historical Society.)

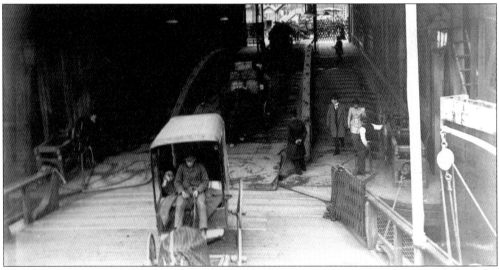

The farmers rose at 3:00 a.m., loaded their horse drawn wagons, and proceeded to the Staten Island Ferry. Along the way they would stop at the "Watering Hole" to refresh themselves and their horses before boarding the ferry to Manhattan. Once there, they went to the Ganesvoort Market or the Washington Market to sell their produce. If they sold their produce, they went home. If not, they stayed at Jim Woltmans's Hotel and Restaurant overnight and returned to the markets the next morning. The second wagon in this Alice Austen photograph could be carrying farm produce as it leaves the ferry at the Manhattan terminal. (Courtesy Staten Island Historical Society.)

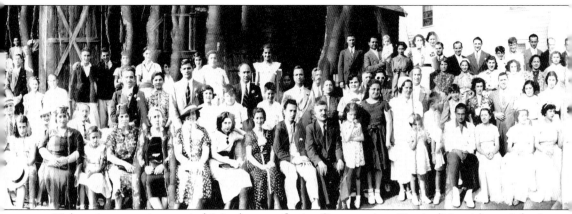

Helen Anagnostis married Manhattan florist Constantine Denis (Ntenis) on July 4, 1937, on the Anagnostis farm. The wedding had to take place on July 4 because that was the only day the florists were closed. The left side of the photograph has the farmers, while the right has the Manhattan florists. The florists came with orchids and lily of the valley, which they hung from the barn. The farmers barbecued seven lambs. They had the food in one barn and the band in the other. There was dancing all day with the

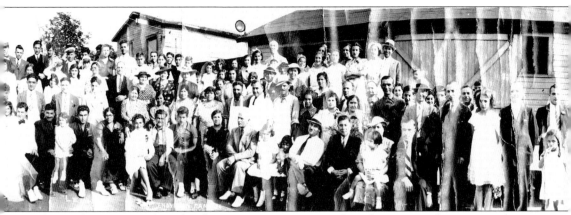

traditional coins tossed at the dancers, so many coins that the younger boys spent the next day digging them out of the dirt. While some Greeks broke dishes at weddings, the Lemnians threw money. Helen and her husband owned Denis Flowers. She says she was "born in a barn on a farm, moved to Manhattan, met actors and actresses, and became friends with Bette Davis." (Courtesy Helen Denis.)

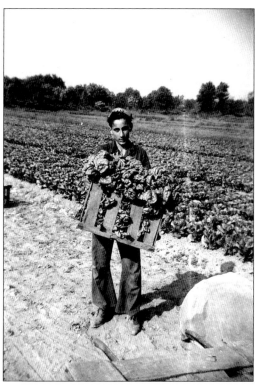

Peter Anagnostis is carrying spinach from the field in 1938. His mother's uncle, Stratis Piromaglou, came to Staten Island before 1900 and rented a farm and barn from the Kaufmans at 24 Merrill Avenue. His uncle, Stelios Anagnostis, was also in Staten Island before 1900 and had a farm "at the end of Merrill Avenue." Anagnostis is credited with bringing many Greeks from Manhattan to work on the farms. (Courtesy Helen Denis.)

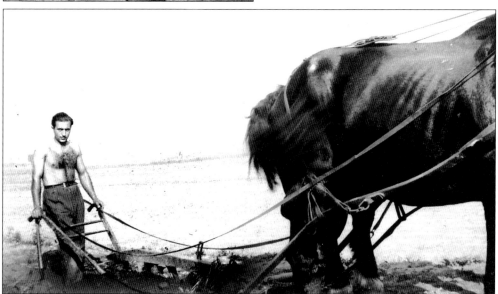

George B. Anagnostis is shown plowing a field behind his horse. George and all of his brothers had the middle initial "B" to show they were sons of Basil Anagnostis, not Stelios Anagnostis. Basil and Anastasia, whom he married for her beautiful eyebrows, had 10 children. Stelios and Harista had eight children. They lived in a long, open house with 20 or 30 children there sometimes. Large families were the norm for the Anagnostis families. Stelios and Basil left Lemnos, a small, rocky island, because their parents had 14 children (13 boys), and there was not enough land to go around. (Courtesy John Anagnostis.)

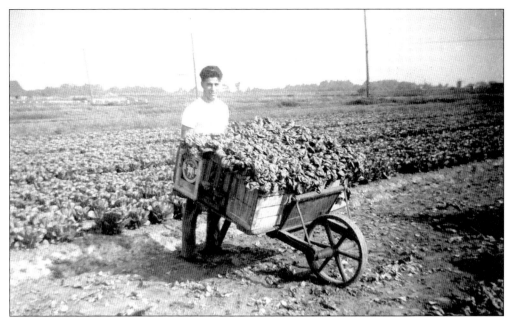

When mud prevented Tim Anagnostis from getting a truck or horse and wagon into the fields he used a hand cart to haul out the spinach. In later years, Tim and his Richmond Hill Road farm were well known to historic Richmond town visitors. (Courtesy Helen Denis.)

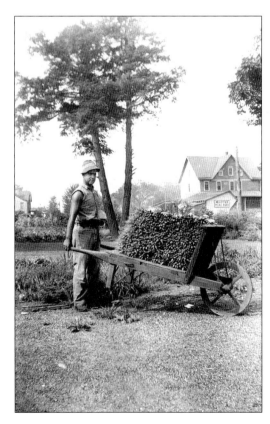

Louis Chrampanis (son of Peter) had his own hand made cart. He is shown in this 1930s image with a load of beets. The building at the back is Fritz's Tavern, which became Henny's Steak House. (Courtesy Gus and Olympia Skunakis.)

25

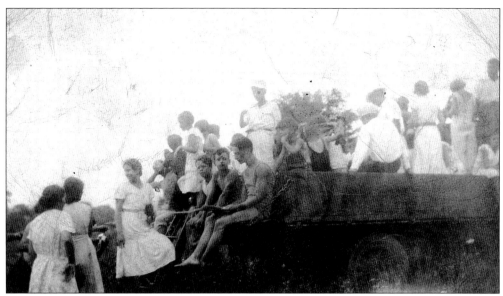

Every Sunday the Anagnostis family piled into the back of their truck to go to Midland Beach. (Courtesy Helen Denis.)

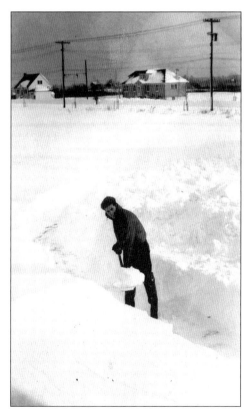

Nick Anagnostis has a lot to shovel. This photograph was developed on January 7, 1948; a memento of a famous blizzard. (Courtesy John Anagnostis.)

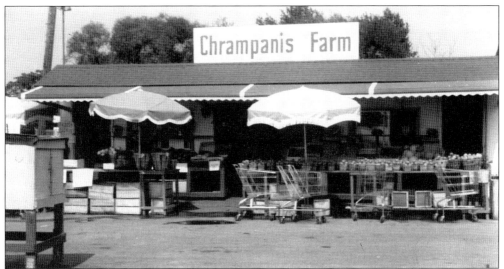

In its heyday, the Chrampanis roadside stand regularly drew people from New York, New Jersey, Pennsylvania, and Connecticut with its succulent array of produce. The main crops were spinach, radishes, scallions, lettuce, string beans, cauliflower, rhubarb, celery, and onions. Anthony and Peter Chrampanis, and Costas Talumbos, bought an apple orchard in 1919. They knew nothing about growing fruit, so they took out the trees and started farming. Eventually, they owned 50 acres in Bulls Head and New Springville. When the taxes got too high, $15,000 and more in 1971, they decided to sell most of their farmland. (Courtesy Gus and Olympia Skunakis.)

The Chrampanis barn was typical of all of the barns. There were rooms at the top for the seasonal workers who came from the spring until the fall. They were given living quarters and meals. George Talumbos described how his feisty mother (maiden name Zacharoula Chrampanis), could be seen out in the fields at 5:00 a.m. then she cooked for her family and the eight or nine workers who lived on the farm. In the cold weather, she put their frozen shoes in the oven to warm them. (Courtesy Louis and Mary Chrampanis.)

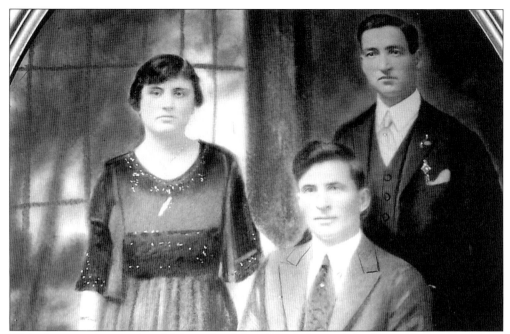

This photograph was taken 15 days after Maria Tambakis and Anthony Chrampanis were married in August of 1921. With them is their *Koumbaro* (best man), Dimos Exarchos. Since there was no church on Staten Island, they were married in St. Nicholas Church on Cedar Street in Manhattan. This building, the "Little Greek Orthodox Church," was destroyed on September 11, 2001. Maria and Anthony had four children: Louis, Pauline, Olympia, and Irene. As was the custom, the Koumbaro christened them all. (Courtesy Gus and Olympia Skunakis.)

George Talumbos is holding a bunch of beets. This photograph was taken after much of the farmland was sold. You can see the earth torn up behind him as construction for homes had started. (Courtesy Gus and Olympia Skunakis.)

Baby Louis Chrampanis is holding a bell rattle. He is the owner of the only remaining farm on Staten Island. (Courtesy Louis and Mary Chrampanis.)

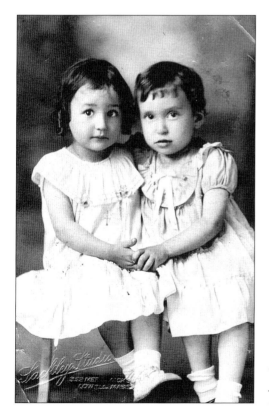

Mary Mondreas (right) and her niece, Sylvia Leventis, were born in Massachusetts. Mary, the ninth of 10 children born to Vasili and Stavroula Mondreas, came to Staten Island at nine years old with her sister Georgia Protopapapas. Mary married Louis Chrampanis, pictured above, on January 4, 1950. (Courtesy Louis and Mary Chrampanis.)

29

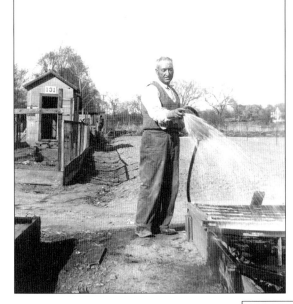

Anthony Chrampanis was watering the lettuce in the hot beds on Easter Sunday, 1946. Glass was used to cover the hot beds. A seed house is shown at the left. Chrampanis was 103 years old at his death in 1990. (Courtesy Gus and Olympia Skunakis.)

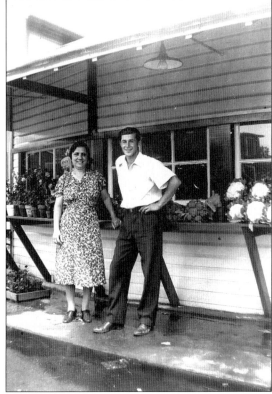

Maria Chrampanis and her godson, Angelo Susalis, enjoyed the beauty of the cauliflower and other produce at the stand on Richmond Avenue. The Susalis family lived in the basement of the Chrampanis farmhouse. (Courtesy Gus and Olympia Skunakis.)

Tony Chrampanis, son of Louis and Mary, used a tractor to bring in produce. The farm went far back into what became Heartland Village. Public School 69 and Intermediate School 72 now occupy the land at the back of what was the farm. (Courtesy Louis and Mary Chrampanis.)

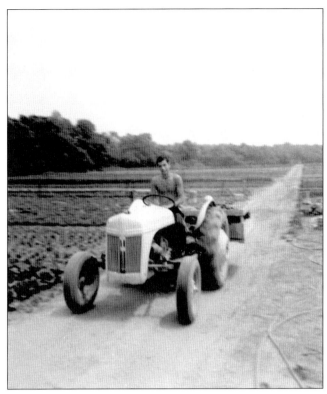

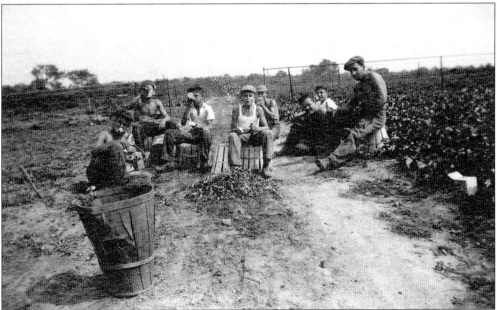

From left to right, Louis "Big Louie" Chrampanis, Louis Chrampanis, Angelo Susalis, George Talumbos, Nick Susalis, Frank Chrampanis, and Peter Hitsous relax in the field. In later years, male workers came up from Puerto Rico from April to October. The farmers provided on-site housing and food. They paid for transportation, Social Security, and all that was needed for them. (Courtesy Louis and Mary Chrampanis.)

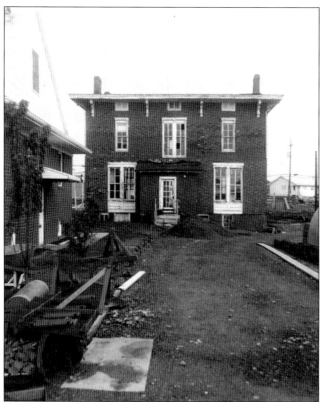

The Chrampanis farmhouse, a familiar site on Richmond Avenue, housed four or more families at a time. Anthony's family, Peter's family, and George Talumbos's family lived on the main floors. The Susalis family occupied a basement apartment. When the city took land from the farm to straighten Richmond Avenue, the family built a new home. The old farmhouse was so sturdy it refused to come down. A claw had to be employed to break it apart. This photograph shows the new house, the old house, and a hot house. It does not show the outhouse which was used up until the 1950s. (Courtesy Louis and Mary Chrampanis.)

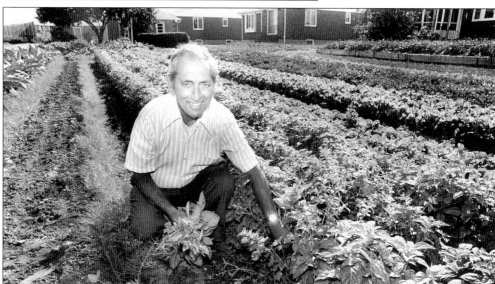

You can see how much Louis Chrampanis loves being a farmer; how perfect the greens are he is holding. Imagine how he and the other farmers felt when they awoke to see not the perfect crops they had when they went to bed, but wilted, brown edged crops ruined by the smog and smoke from New Jersey in the 1960s. The Staten Island Growers Association was able to get monetary compensation for the thousands of dollars farmers lost each year. (Courtesy Louis and Mary Chrampanis.)

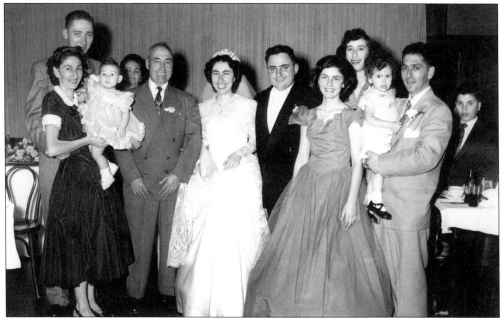

On January 25, 1953, Olympia Chrampanis married Gus Skunakis. Their farms were across the road from each other. This wedding photograph shows the Chrampanis side of the family. From left to right are Ray Uske, Pauline Uske (holding daughter Mary), Efthemia Exarchos, Anthony Chrampanis, Olympia and Gus Sunakis, Irene Chrampanis, Mary Chrampanis, Louis Chrampanis (holding daughter Georgia), and John Skunakis. (Courtesy Gus and Olympia Skunakis.)

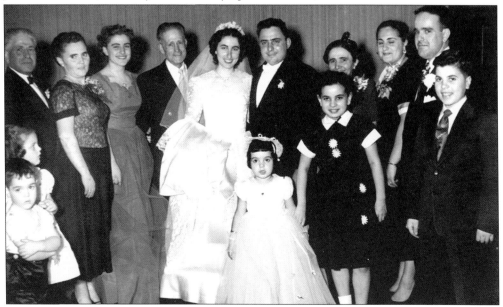

The Skunakis side of the family is pictured here. From left to right are Stratis Skunakis, Chrisanthy Skunakis, Sophie Skunakis, Nick Skunakis, Olympia and Gus Skunakis, flower girl Jeannie Routsis, Stella Skunakis, Anna Skunakis, Stella Routsis, Gus Routsis, and John Skunakis. The children at left are unidentified. (Courtesy Gus and Olympia Skunakis.)

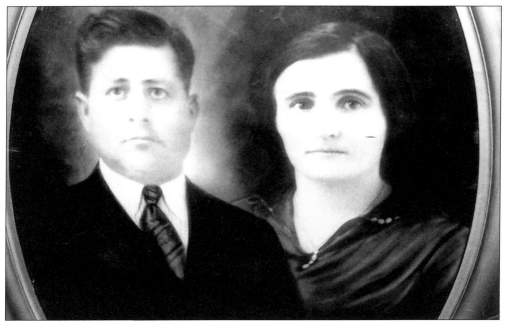

Nicholas Skunakis went to Italy to get his bride, Anna Exarchos. They were married in Naples in 1923. Anna, the twin sister of Dimos Exarchos, was born in Platanos, Greece. Dimos Exarchos and Nicholas Skunakis jointly owned the Exarchos farm on 47 Travis Avenue. Nicholas Skunakis was the chanter at Holy Trinity Church for 30 years. Because of his long service, and because St. Nicholas is the patron saint of islands, St. Nicholas was added to that of Holy Trinity, making the church Holy Trinity-St. Nicholas Greek Orthodox Church. (Courtesy Gus and Olympia Skunakis.)

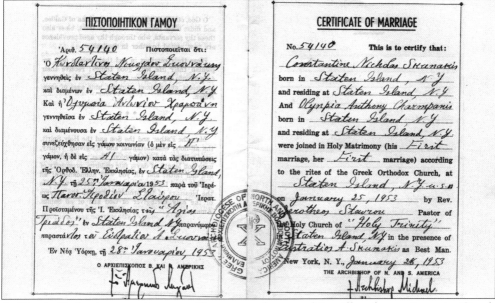

A Greek Orthodox marriage certificate was then, and is still today, written in Greek and English. This is the marriage certificate of Olympia and Gus Skunakis. (Courtesy Gus and Olympia Skunakis.)

Stratis Skunakis lived on Staten Island for many years before he decided to marry. He was 44 when he went to Greece for his 24-year-old bride, Chrisanthy Savakis. She was one of 12 children from a wealthy family in Crete. She lived in a mansion with a *kafenio* (coffee shop) beneath it. They are standing in front of the Erechtheion, the Caryatid Porch at the Acropolis. (Courtesy Stella Vlastakis.)

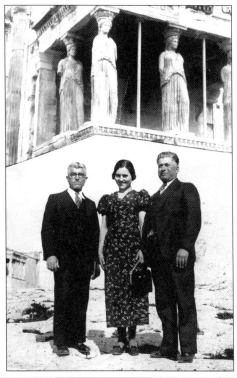

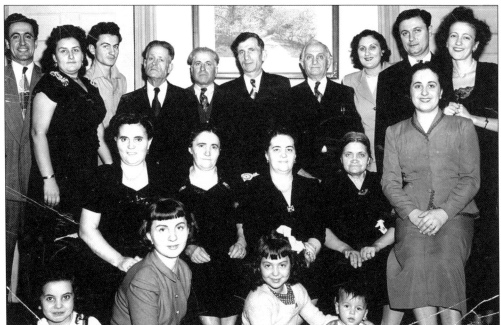

The Exarchos Farm housed these four families and encompassed a large area on Travis Avenue. Dimos Exarchos and Nick Skunakis lived with their families in an eight room house at 86 Travis Avenue. The Telegadis family lived above the barn at 107 Travis Avenue. This barn was moved to Historic Richmond Town. The Stratis Skunakis family lived in a house at 24 Signs Road. (Courtesy Stella Vlastakis.)

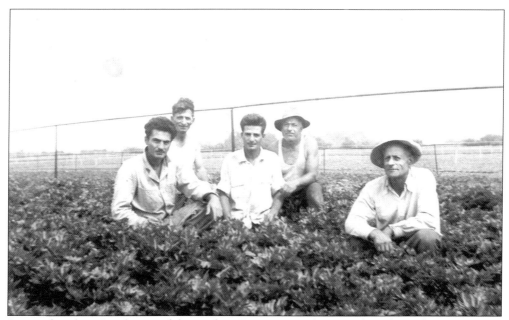

It was already a Greek owned farm when Dimos Exarchos purchased it. The main crops were beets, lettuce, spinach, celery, dandelions, cauliflower, onions, and scallions. From left to right, Andrew Exarchos, Dimos Exarchos, and Gus Exarchos are working in the field with Stratis Skunakis and Nick Skunakis. (Courtesy Gus and Olympia Skunakis.)

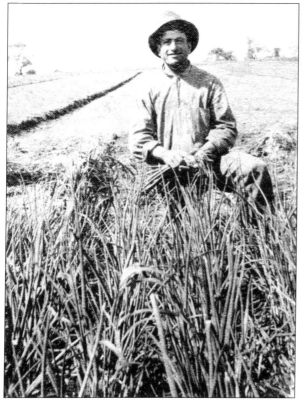

Stratis Skunakis is picking scallions in the Travis Avenue field. (Courtesy Stella Vlastakis.)

Andrew Exarchos, son of Dimos and Efthemia, is getting into the fully loaded truck to take the produce to market. (Courtesy Gus and Olympia Skunakis.)

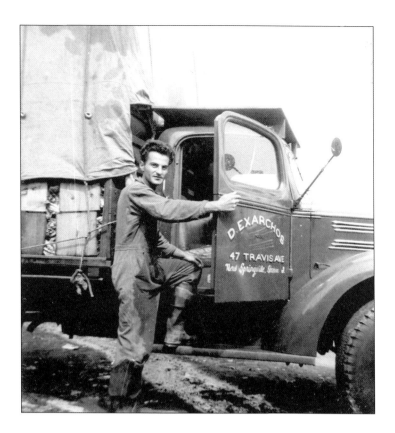

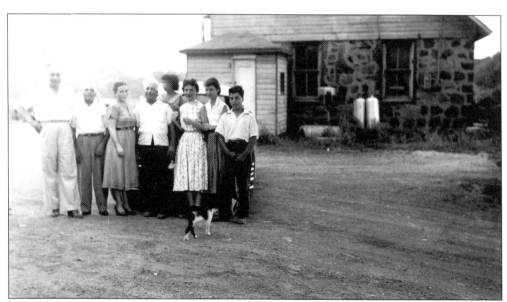

From left to right, Senator George Tsatsanis, Manoli ?, Chrisanthy Skunakis, Stratis Skunakis, Jeannie Routsis, Georgia Exarchos, Kiki Exarchos, John Skunakis, and cat "Tsiptsina" are in front of the barn on Signs Road. (Courtesy Stella Vlastakis.)

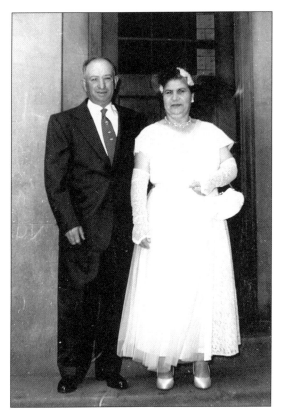

John Itsines came from the island of Kos to avoid the Turkish army. He worked on the Katsaros farm, rented the farm at 145 Merrill Avenue from the Exarchos family, and then bought it. After he brought his sisters here, they all stayed on the farm. He is shown with his wife, Bessie, at the wedding of their son Nicholas in the 1950s. (Courtesy Madeline Johanides.)

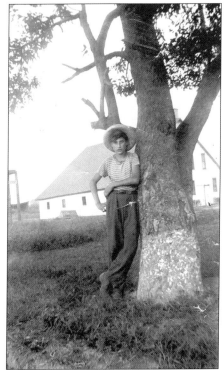

Gus Itsines, youngest of seven children born to John and Bessie Itsines, leans against a tree. (Courtesy Madeline Johanides.)

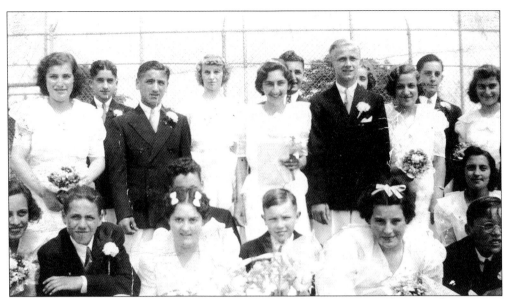

In 1938, Madeline Itsines graduated the eighth grade from PS 22. She is at the top row, left. Other farmers who graduated with her are Pauline Chrampanis, top row fifth from left; Molly Tambakis, top row right; and Helen Hatsis, bottom row left.. The principal, M. L. Pease, and the teacher, E. B. Maynard, required that the girls sew their own dresses. (Courtesy Madeline Johanides.)

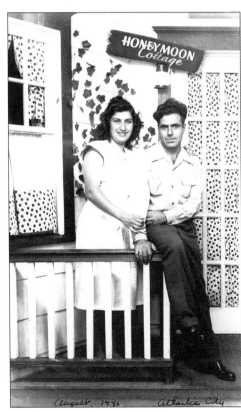

Nick and Madeline (Itsines) Johanides honeymooned in Atlantic City in August 1946. Many newlyweds went to Atlantic City, New Jersey, or to the Greek hotels in the Catskill Mountains of New York.

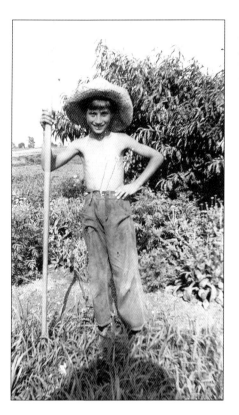

Gus Itsines is working the field with his hat on his head and his hoe in his hand. It looks like he does more posing than working. (Courtesy Madeline Johanides.)

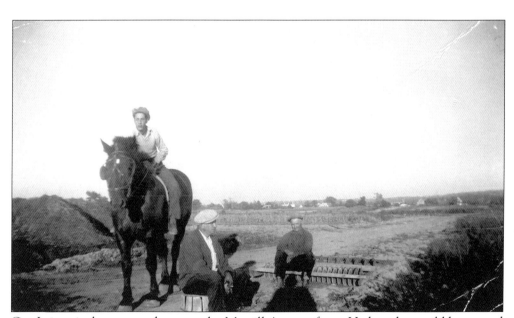

Gus Itsines is shown on a horse at the Merrill Avenue farm. He bought a wild horse and tamed it. He didn't use a tractor to till the field, the horse pulled the tiller. Arlene Street is behind him. (Courtesy Madeline Johanides.)

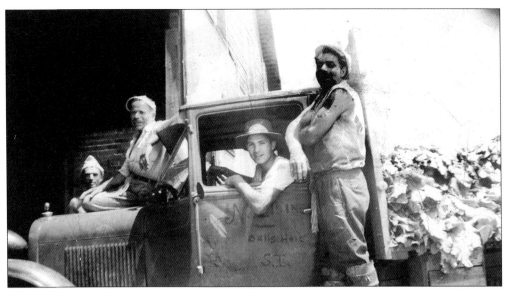

From left to right, Matthew Kafes, Jimmy "the Colonel" Sfoungaris, Nick Itsines (driving), and Nick Johanides are off to market with a truckload of produce. (Courtesy Madeline Johanides.)

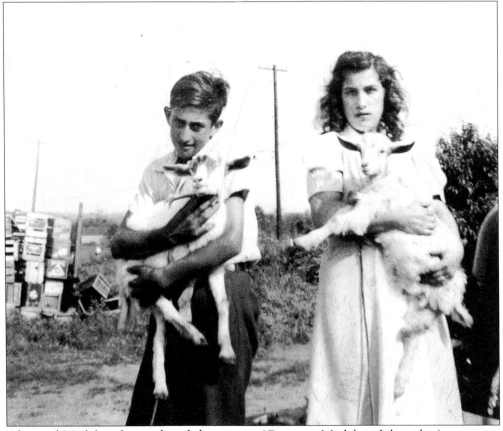

Alex and Madeline Itsines loved their goats. (Courtesy Madeline Johanides.)

This 1943 photograph shows a young Ted Kefalianos and a portion of the Kefalianos farm, which included two barns, a stable, and men's quarters. The workers lived in Manhattan in the winter, but came to live on the farm each summer. Dionysia Kefalianos did the laundry, the beds, and cooked for all. The workers became like family members. (Courtesy Mary Menichella.)

Gus and Madeline Itsines were visiting the Kefalianos farm. The farm they rented was next to the Tsourekias farm on Lamberts Lane. Madeline is wearing a persian coat popular in the 1940s. (Courtesy Madeline Johanides.)

Dionysia and Anthony Kefalianos joined brother Tom Kefalianos as partners on the rented farm. They raised four children: Evelyn, Mary, Kate, and Teddy. The farm was rural. Mary remembers hoping that none of her friends at Hunter College would want to visit because they still had an outhouse on the farm. The Itsines, Pavalis, and Kefalianos families were a closely knit group. Since they had no phone, cousins Catherine Itsines and Mary Kefalianos would shake a sheet to signal each other to meet and play. (Courtesy Mary Menichella.)

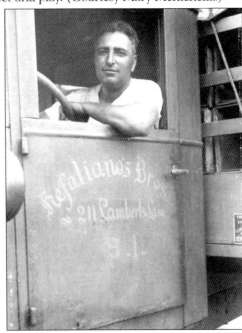

Anthony Kefalianos is shown here in his truck. When the children went to school, somehow an "a" was dropped from their name, and they became known as Kefalinos. (Courtesy Mary Menichella.)

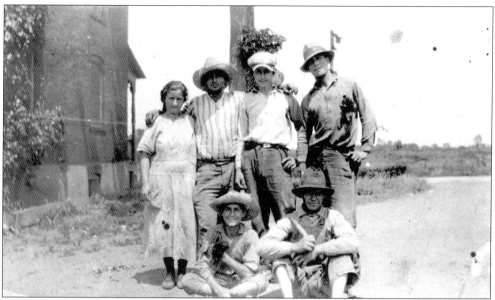

Dionysia and Anthony Kefalianos (top left), were relaxing with brother Tom Kefalianos (top right), and unidentified friends on the Kostandelis farm one hot summer day. Helen Corinotis, daughter of Fannie and Costas Kostandelis, says they sold their farm at 210 Merrill Avenue one lot at a time before the bridge went up. (Courtesy Mary Menichella.)

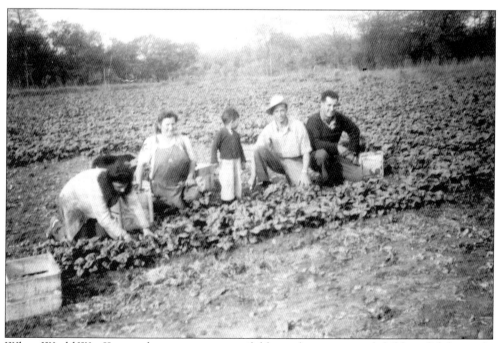

When World War II started, men were not available, so the women and children did the work. From left to right, Evelyn Kefalianos, Dionysia Kefalianos, Teddy Kefalianos, Mike Constant, and Harry Pavalis cut the spinach before going off to school. The background shows where the Staten Island Expressway is now at Lamberts Lane. (Courtesy Mary Menichella.)

Antonio and Eleni Psomas are shown here on their wedding day. They lived in Manhattan for five years before coming to Staten Island to become farmers. (Courtesy Bessie Psomas.)

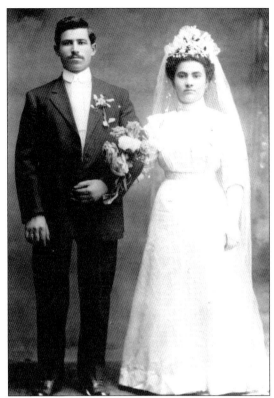

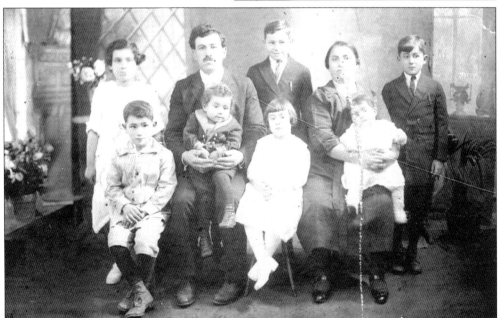

The Psomas family sat for this photograph with seven of their eight children. From left to right are (first row) Gus, Antonio (holding Ody), Mary, and Elini (holding Eugenia); (second row) Katherine, George, and Alex. Their son Peter had not been born yet. (Courtesy Bessie Psomas.)

Eleni Psomas is shown holding her granddaughter Elaine in this 1946 photograph. Victory Boulevard was sparsely populated then. (Courtesy Bessie Psomas.)

The Psomas farmhouse, the Psomas family, and even the pet dog were well known throughout the neighborhood. Antonio and Eleni Psomas rented the house and farm at 3301 Vistory Boulevard from the Chrampanis family. It was in the kitchen of this farmhouse that a city schoolteacher came to teach English to Eleni and some of the other women. The women received certificates of achievement for these classes. (Courtesy Linda Ritchie.)

Peter Psomas was picking radishes or beets by the bushel that day on the farm. (Courtesy Peter Psomas.)

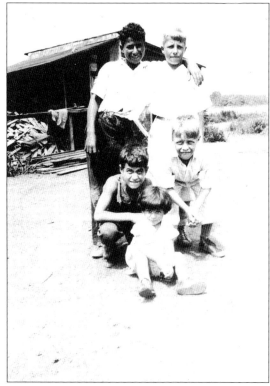

The Psomas boys and friends pose in front of the barn work area. From left to right are (first row) Steffi Susalis; (second row) Peter Psomas and Russell Thompson; (third row) Odysseus "Ody" Psomas and Elwood Thompson. (Courtesy Peter Psomas.)

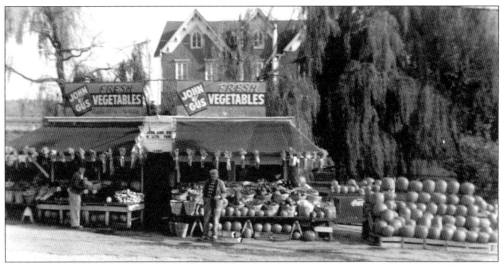

The stand belonging to cousins John Bakalis and Costas Thanasoulis was located at 2209 Richmond Avenue. On this fall day, you can see pumpkins and hanging ears of corn as well as their other crops: carrots, lettuce, rhubarb, scallions, squash, cucumbers, beets, beans, and tomatoes. Behind the stand are weeping willow trees. Thomas Thanasoulis remembers his father cutting branches one or one and a half inches thick and sticking them directly in the ground. They would grow because the ground was so moist from a brook on the property. Thomas's sister, Hariclea Thanasoulis, describes the Victorian house which is visible behind the trees as "having a wrap-around porch and high gables. The fireplaces were made of marble . . . opera chandeliers . . . no electricity . . . the upstairs had wood carvings made to look like marble . . . bas-relief . . . a pyramid scene." The beautiful Victorian house of her memory was bulldozed in 1962. (Courtesy Stella Thanasoulis.)

A serene brook meandering along the property of Gus Thanasoulis originated near Latourette Golf Course. It came from behind the last field of the 15 acre farm. Hariclea Thanasoulis remembers taking her books there to read. Costas Thanasoulis planted white mulberry trees on the property because they reminded him of the mulberry trees in Greece. The white mulberries were delicious, and the tree provided son Thomas with a perfect seat for contemplating the world. The tree was so dense that he would climb up about four feet, sit on one branch, lean his back on another, and put his feet up on a third branch. Their home is just visible at the top of the photograph. (Courtesy Stella Thanasoulis.)

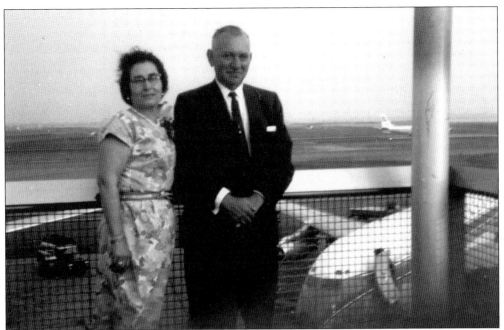

Costas and Stamatia Thanasoulis were at the airport along Richmond Avenue in July 1963. The Staten Island Mall and other shopping plazas now occupy this space. (Courtesy Stella Thanasoulis.)

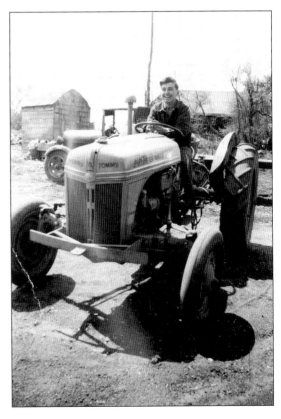

Thomas Thanasoulis's first set of wheels was this tractor. He remembers an earlier time when he would accompany his father to Manhattan bringing produce to market in the farm truck shown at the back of the picture near the outhouse. Costas Thanasoulis sang "The Bells are Ringing" at the top of his lungs, with a Greek accent, of course. (Courtesy Thomas Thanasoulis.)

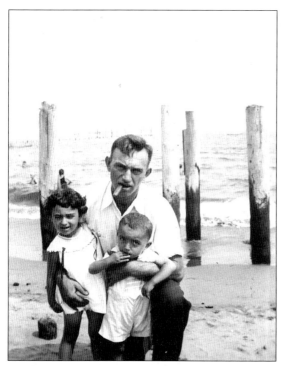

When Costas Thanasoulis first came to America, he had to earn money for his sisters' dowries back home, so he worked at Coney Island. That's where he learned to love the beach. He enjoyed taking his children, Hariclea, Pericles, and Thomas (not pictured here) to South Beach. (Courtesy Stella Thanasoulis.)

The dark winter evenings were difficult for farmers, who were used to working outdoors, since they had little to occupy their time. Costas Thanasoulis would go to Manhattan after Christmas each year to Macy's or to Hearn's on Fourteenth Street. One day while he was browsing, he saw a demonstration on punch needle embroidery. He brought the velvet and the yarn home to his wife, but she couldn't do it. So Costas created punch needle artwork himself. He made an altar hanging for the church as well as pillows and wall hangings. His grandchildren have them in their homes today. (Courtesy Stella Thanasoulis.)

Jordan and Eleni Tsourekias were born in Lemnos, Greece, but married here. Jordan lived with Basil Anagnostis before his marriage, then moved to Stelios Anganostis's house. They had four girls: Penelope (left), Francis (center), Fertina (right), and Georgia (not pictured). (Courtesy Georgia Baboulis.)

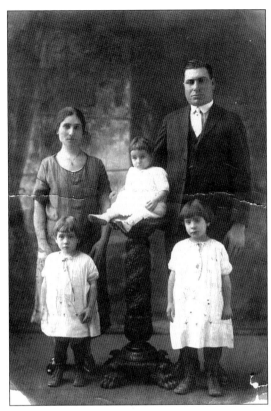

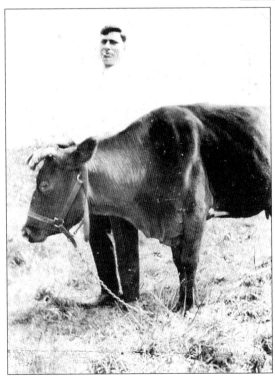

Jordan and Eleni Tsourekias purchased a farm at 199 Lamberts Lane. He is standing behind his cow in this image dated July 22, 1924. (Courtesy Georgia Baboulis.)

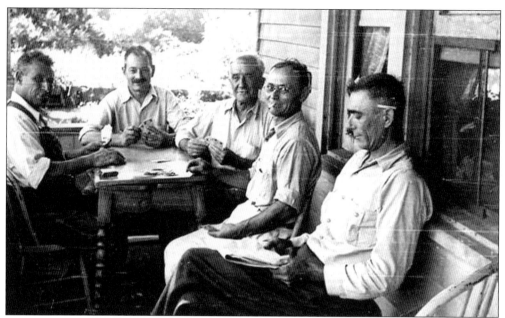

From left to right, Anthony Psomas, Nicholas B. Sideris, Costas "Barbacosta" Thanasoulis, and Emanuel Criaris are enjoying an afternoon card game. John "the Worker" Leondis joined them on the porch of the Psomas farmhouse. (Courtesy Elaine Moran.)

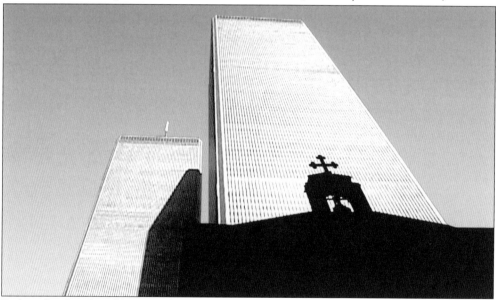

Before the Greeks of Staten Island built Holy Trinity, they went to St. Nicholas Church on Cedar Street in Manhattan. Even after many years, they retained their ties with, and love for, this little church. When it was destroyed on September 11, 2001, their hearts were broken. Gregory Grisha Ressetar's famous photograph *St. Nicholas in Shadow on the World Trade Center* is etched in their hearts and minds. In addition to losing the church, Staten Island's Greek community lost Vassilios Haramis and Jennifer Tzemis on that day. Some made it safely home; others lost loved ones in other boroughs. For all that were lost, "May their memory be eternal!" (Courtesy Gregory Grisha Ressetar.)

Three

THE PORT RICHMOND GREEKS

Growing up in Greece, I remember playing with my friends through miles of ancient city streets, near ancient houses and temples which served as our playgrounds, so to speak.
—His Eminence Archbishop Demetrios of America Richard Stockton College of New Jersey, October 31, 1999

They left the land of Aristotle, the Acropolis, the Parthenon, the ancient cities, the ports, the seas, the islands, the time hewn rugged, rocky hills of Lemnos, Kos, and Crete. They came from places like Sparta, Navpaktos, and Asia Minor and settled on Staten Island's marshes and farmlands, or did they? For some, the farm life was not appealing. They preferred the busy hub of activity that was Port Richmond.

This section of Staten Island had history. At the end of the 17th century, it was known as the Burial Place, and was called, at various times, Decker's Ferry, Ryer's Ferry, Mersereau's Ferry, Cityville, and Bristol. The name, Village of Port Richmond, was suggested by Rev. Dr. Brownlee and incorporated by an act of the Legislature on April 24, 1866. At the time Greeks first started coming to Staten Island, it was also known as the Model Village because of its neatly kept streets. Port Richmond had everything: a business district, beautifully manicured homes and properties, a school, a railway, a trolley, steam ferries, a hotel, a bank, a movie theatre, and more. For those who didn't choose the farm life, Port Richmond was the answer.

Port Richmond is on the north shore of Staten Island. Many magnificent examples of Classic Greek Architecture can be seen by traveling along the north shore. Imagine the joy and pride the Greeks felt when they first saw the glorious Greek Revival buildings of Sailors' Snug Harbor, the "Captains' Row" of Greek Revival houses in Port Richmond, and residences in Stapleton and New Brighton of the same style. As they approached the St. George Ferry, the neo-classical Richmond County Courthouse with its temple front portico must have reminded them of their homeland's architectural treasures and given them first a sense of nostalgia, but also a sense of how much America valued the Greek heritage, even on little Staten Island.

No businesses with Greek names would be found in the archives, because the Greeks felt that their names were too ethnic for business purposes, and there was some prejudice against the immigrants. However, there were quite a few Greek businesses along Richmond Avenue, and in the Port Richmond area, especially from 1930 on. The businesses are now long gone, as are the glory days of Port Richmond, but it was an entrepreneurial start for many families.

Since so many Greek families had settled in Port Richmond, it was the starting place for the Aristotle Society, an organization dedicated to keeping the Greek culture, history, and language alive in Staten Island. It was this society that evolved into Holy Trinity Church.

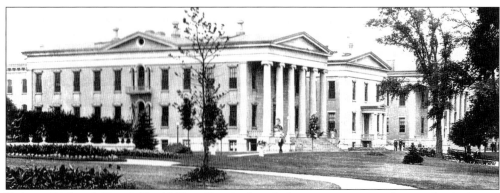

Robert Richard Randall's 1801 will stipulated that a retirement home for indigent sailors be built with eight trustees to oversee it. His family owned Washington Square in Manhattan, so the trustees sold that property and acquired the Houseman farm on the north shore of Staten Island for this purpose. Architect Minard Lafever was awarded $50 for winning a building design contest. His concept was to build in Greek Revival style sending a message of power and democracy. The first building opened in 1833. Additional buildings were added by 1880. Only 37 men entered in 1883, but at its peak, the great years of 1889 through 1940, Sailors' Snug Harbor housed 1,000 men in what was a regulated, moral existence. It was a cross between a social institution, a hospital, and a prison. It was these magnificent buildings and others in the Greek Revival style on the north shore of Staten Island that must have given the early Greeks a feeling of being home. (Courtesy Staten Island Historical Society.)

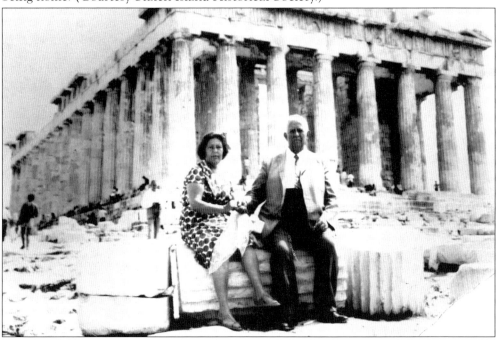

James and Georgia Katsoris sat on the steps of the Parthenon in Athens on a trip to Greece. James came to work in the ice cream parlor with his cousin Emmanuel Katsoris. James later became a partner in that business. They brought Georgia's nieces and nephews Julia, Gus, Nick, Elizabeth, John, Helen, Peter, and their mother Martha Panagakos from Sparta to America in the 1950s. (Courtesy Elizabeth Papas.)

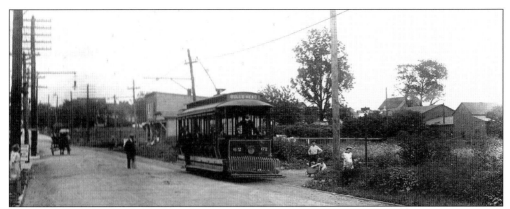

The trolley ran from Port Richmond to Bulls Head allowing the Greeks passage from one area to the other. This 1912 image shows the trolley at the intersection of Richmond Avenue and Catherine Street. The Chrampanis family did not have enough money for a car, so they rode bicycles everywhere. During a snow storm, the trolleys put a tractor on the front of the car to clear the tracks. Since the trolley tracks were the only area cleared, Peter Chrampanis would ride his bicycle down the tracks on Victory Boulevard then proceed to Port Richmond. Unfortunately, during one such storm, Peter was killed by the trolley. (Courtesy Staten Island Historical Society.)

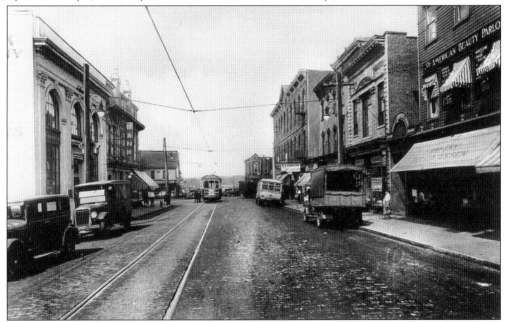

This photograph, taken sometime between 1905 and 1915, shows Richmond Avenue looking down toward Port Richmond Square. Here, in no special order is a partial list of Greek owned Port Richmond businesses and their owners: Candyland Shop (Caffentzis), Flower Shop (Katsaros), Palace Pressing (Passias), Central Dry Cleaners (Pappas), Port Richmond Candy Square Kitchen (Katsoris), Auto Driving School (Dallas), New Dinette (Vallas), Spa Restaurant (Vallas and Sigalos), Tuscana Market (Mikroutsikos), DeLux Candy Shop (Eliopoulos), New York Confectionery (Katsoris), and later on Perry's Luncheonette (Thanasoulis), Shoe Repair (Papas), and the Port Richmond Deli (Rassias). (Courtesy Staten Island Historical Society.)

Public School 20 started on Heberton Avenue in the 1860s. By 1915, a second building was added. Children went to the eighth grade at PS 20 and then moved on to different high schools. Peter and George Katsoris remember a teaching duo, Mr. and Mrs. McFadden, who sent the boys to deposit their checks in the bank next to their father's ice cream parlor. Greek mothers sat talking in the beautiful park, while waiting for their children to be dismissed. The children spoke only Greek when they entered PS 20. They learned English at school. There is still a Greek connection; George Thanasoulis, has been the school's fireman for many years and Chris Loizos is the custodian. Christine Charitis taught at PS 20 for 26 years before retiring in 2003. (Courtesy Staten Island Historical Society.)

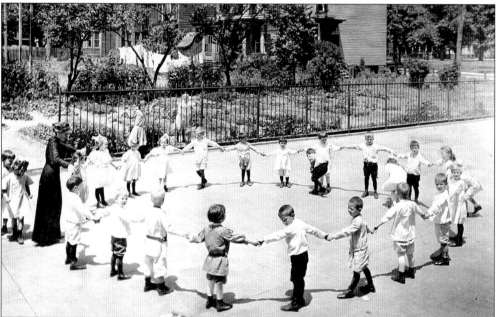

Children have always danced and played circle games in kindergarten. The Katsoris boys, although not pictured here, remember wearing knickers to school at PS 20. (Courtesy Public School 20.)

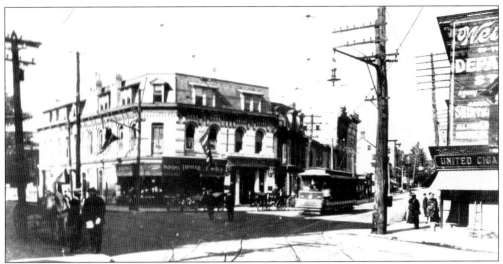

In 1911, after having spent 10 years in Chicago, apprenticed to his godfather in an ice cream parlor for $30 a month, Emmanuel Katsoris had a fruit and vegetable business in Elizabeth, New Jersey. He took the Elizabethport Ferry to Staten Island and traveled with his horse and wagon along Richmond Terrace to the St. George Ferry to get to Manhattan where he purchased fruits and vegetables at the Washington Square Market. One day he saw a vacant store in Port Richmond Square and decided to rent it. Thus began the Katsoris business at 2064 Richmond Terrace. (Courtesy Staten Island Historical Society.)

Emmanuel Katsoris was born in Molaos, Greece. His father died before he was born, so when he was 18, his mother sent him to America. He arrived on the S.S. *Oriole* in 1901. He married Catherine Exarhakis, and they had four children: George, Peter, Rose, and Betty. (Courtesy Peter and Georgia Katsoris.)

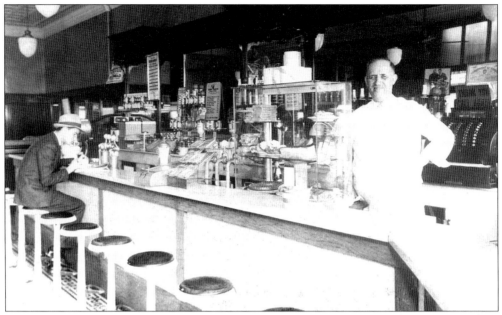

Emmanuel Katsoris is shown at the counter of his Port Richmond Candy Square Kitchen in this 1930 photograph. The ice cream parlor moved to 2060 Richmond Terrace in 1926 and remained there until his death in 1952. It was a popular gathering place, with crowds coming after movies at the Palace and Empire Theatres and after high school sports events. Initially, sons Peter and George took buckets of ice cream and sold them on the street. (Courtesy George and Evangeline Katsoris.)

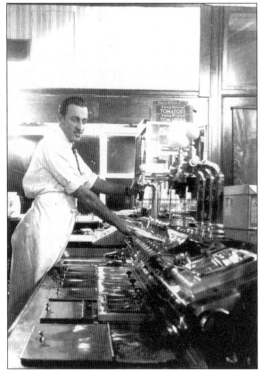

George Katsoris worked in the Candy Square Kitchen (New York Confectionery) with his family for many years. This 1939 image shows the area behind the counter. The ice cream parlor had a tin-coated ceiling with overhead fans. A Wurlitzer nickelodeon supplied the music; potted palms and a marble fountain decorated the large dining area. In addition to ice cream, the Katsoris family made candy, stirring the chocolate in big copper pots. The Katsoris's ice cream and candy businesses evolved into two hugely successful candy companies, Superior Confections and Supreme Chocolatier. (Courtesy George and Evangeline Katsoris.)

When Peter Katsoris (right) returned from serving in Europe in World War II, he borrowed $2,500 from the government to open Kaye Candies. The "K" stood for Katsoris. Kaye Candies produced chocolate covered stem cherries. George Katsoris had worked for Christo Poulos making glazed fruit. George joined Peter. They moved to 16 Osgood Avenue, an old school building which had formerly served as a Women's Army Corps building in World War II and formed Superior Fruit Processing Company. (Courtesy Peter and Georgia Katsoris.)

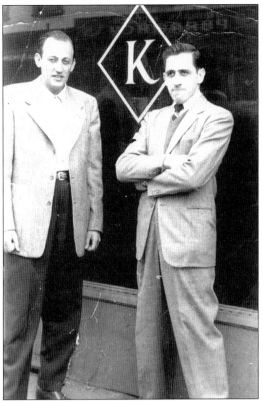

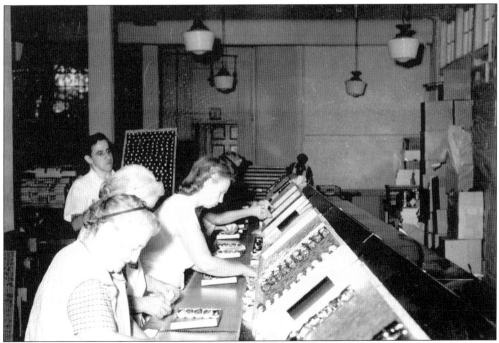

This image, reminiscent of a famous *I Love Lucy* scene, shows the assembly line at the Osgood Avenue factory in 1951. (Courtesy George and Evangeline Katsoris.)

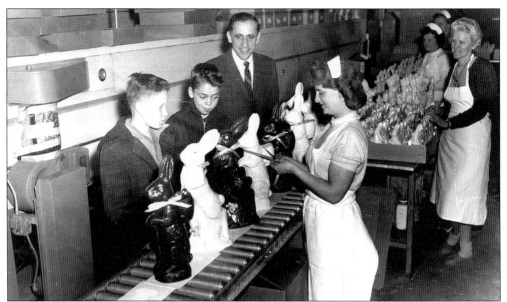

By 1959, the Katsorises had moved their candy business to a building in Richmond Town. This 1959 image shows young boys admiring the chocolate Easter bunnies being decorated on the assembly line as Peter Katsoris looks on. (Courtesy George and Evangeline Katsoris; photographer Jim Romano.)

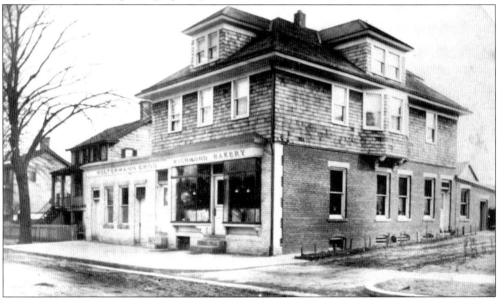

With its name changed to Superior Confections, the Port Richmond Candy Square Kitchen factory moved to 240 Center Street in 1955. This historical building had housed Hathaway's and later, Holtermann's Bakery. From here, Superior Confections built a factory at Industry Road in Travis. After acquiring Blum's of San Francisco and the House of Bauer, this once small Port Richmond Candy Square Kitchen had transformed itself into a worldwide business. The business, now known as Supreme Chocolatier, offers tours and a movie depicting the history of chocolate at their new facility, 1150 South Avenue, in Bloomfield. (Courtesy Staten Island Advance.)

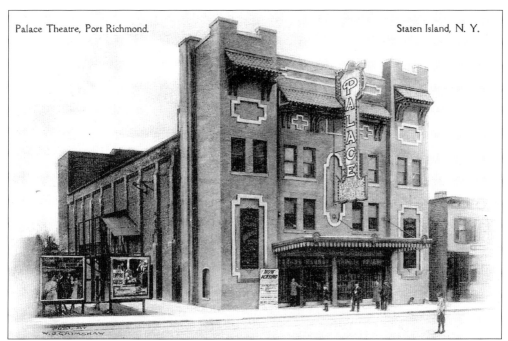

Palace Theatre, Port Richmond. Staten Island, N. Y.

Port Richmond, the Times Square of Staten Island, was home to three movie theatres. The Palace opened in 1915 and brought "Talkies" to Staten Island. Other theatres were the Empire and the Ritz. None of these remain today, but in the good old days they were quite a bargain. A double feature (two full length films), cartoons, a newsreel, and one or more shorts cost 30¢. Every big town on Staten Island had one or more movie theatres. (Courtesy Staten Island Advance.)

Times were very tough in Greece during World War II, so Charles Pappas, president of the church in 1941, convinced owners of the five biggest movie theatres to allow monetary collections during intermissions. Pictured here are Mary Kefalianos (left) and Evelyn Kefalianos who, along with Catherine Itsines, Stella Skunakis, Chrisanthi Telegadis, Hariclea Thanasoulis, and Georgia Tsourekias, went to the Palace Theatre, the Ritz Theater, and other theaters dressed in Grecian costume. They collected $11,000 to send to the Greek War Relief. (Courtesy Mary Menichella.)

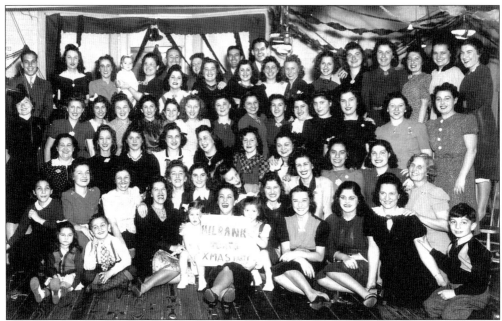

When girls became old enough to work outside the homes and farms, they took jobs in factories. Four farmers' daughters worked at Milbank Hats on Broadway, West Brighton: Madeline Itsines, Lefty Dorgas, Molly Tambakis, and Helen Corinotis. Madeline Itsines (third row, third from right) is enjoying a company Christmas party in the late 1930s. (Courtesy Madeline Johanides.)

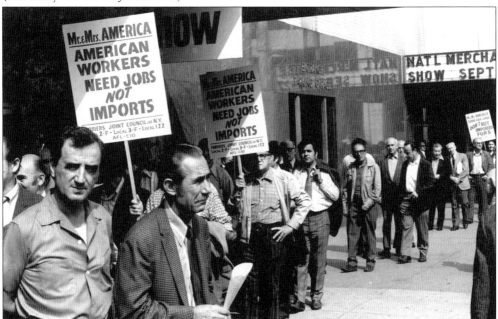

Many Greeks worked as furriers. There were four categories: closers, nailers, finishers, and sewers. James "Jimmy the Closer" Tsikteris, worked for Radley Furs and Levine Brothers for 57 years. Tsikteris, second from left, is walking the picket line during a strike. (Courtesy James and Mary Tsikteris.)

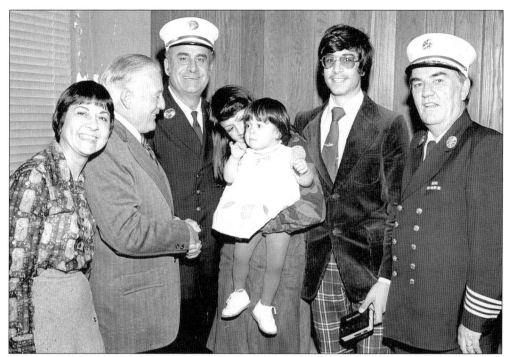

Peter Psomas left the farm to work for the New York Fire Department. He is shown with his family and fire department officials when he was promoted from lieutenant to captain in April of 1976. (Courtesy Peter and Georgia Psomas.)

George Morafetis came from Brooklyn with the opening of the Verrazano Bridge at a time when many people owned horses. He worked as a blacksmith shoeing horses all over the island. When the blacksmith trade faded out, he did what many Greeks before him did. He bought pushcarts and sold hot dogs. Many Islanders know him from his stands at Midland Beach and Tottenville Pool. He has since become an actor, and has won Best Actor Award from the Columbia University Film Festival in 2001 for *Nico's Restaurant*. (Courtesy George Morafetis.)

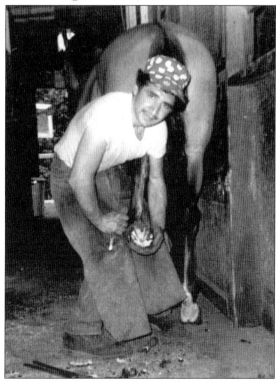

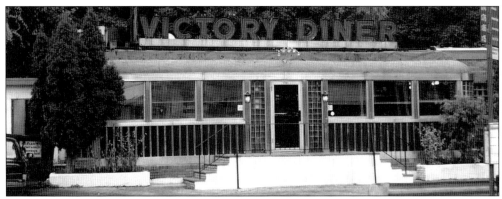

The Victory Diner has the longest history of any of the Greek owned diners on Staten Island. It started on Victory Boulevard and Manor Road and was moved to Dongan Hills in 1964. While on Victory Boulevard, it served briefly as the Staten Island Savings Bank in 1961. Because its stainless steel and Formica finish give it the "streamliner" look of dining cars on the railroads, it is popular with movie crews. In fact it has been filmed for movies and television. *Easy Money*, starring Rodney Dangerfield, and *The Education of Max Bickford*, starring Richard Dreyfuss, are two of the best known productions. Paris Pappas bought it in 1982. His wife, Maria, and sons run it to this day. (Courtesy Staten Island Advance.)

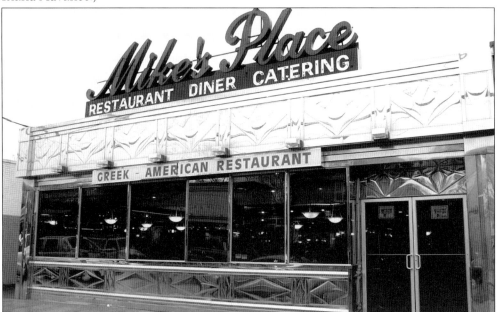

When people think of Greeks, they think diners. This is true on Staten Island too. Mike Moudatsos is the owner of all the Mike's Diners located throughout the Island. Other Greek diners and their owners are: Amboy (Vasiladiotis), Andrews (Plaitis), Annadale (Bakousis and Kheir), Colonnade (M. Platis), Colonnade II (A. Platis), Golden Dove (Theodoulou), Island Coffee Shop (Bakratsas and Thanasias), Kings Arms (Koutsovasilis and Eliopoulos), New Dakota (Pefanis), Unicorn (Diamondakis, Koulouris and Leunes), and Woodrow (Bakousis and Kheir). Catering Halls and restaurants now run by Greeks include the South Shore Country Club (Marangoudakis) and Café Del Mondo (Markos). Greeks still do not use their last names. (Courtesy Staten Island Advance.)

Four

BUILDING A CHURCH

The spirit of unity, embedded in love for our Church and for one another,
is the most important element in a true Christian Community.
—Reverend Spiro Macris, 1973 Church Journal

Although freedom of worship exists in Greece, the official religion is, and has been, Greek Orthodoxy. School children pray together each morning, and religious classes are part of the educational program. Almost every city, town, and village has its patron saint whose yearly feast day is cause for celebration. People are named after saints, and many people celebrate their name day (their saint's feast day) with as much joy as we celebrate birthdays here in America. Celebrations begin with church service and continue into the night. The night is filled with sensory delights: the sound of music from the clarinet and bouzouki, the sight of people dancing in colorful costume, the smell, and ultimately, the taste of lamb roasted on the spit. Everyday life is centered on the church and anchored by faith.

Imagine the loss; imagine leaving your homeland, your family, your village church, and living in a land where the language, the culture, the work, the everyday life is so different. For the Greek immigrants who settled on Staten Island, the nearest church was St. Nicholas Greek Orthodox Church in Manhattan. They went infrequently because going to church was an all day affair. They left at 7:00 a.m. and had to take the ferry to Manhattan. They brought their lunch with them because they would be gone for such a long time.

When they began to marry and start their own families, they realized that it would be difficult to raise their children in an atmosphere that included their religion, language, and heritage without a church or Greek school. According to Dr. Nicholas Itsines, who wrote a history of the first 50 years of Holy Trinity Church, by 1926 there were a total of 54 children within the Greek community (27 from the Anagnostis and Psomas families alone). In 1927 they started the Greek Educational Society of Aristotle, Incorporated, which led, in time, to the formation of Holy Trinity Greek Orthodox Church.

The society held its first annual dance at the Masonic temple in Port Richmond, and raised the sum of $2,250, a substantial amount for the time. By 1929, the decision was made to purchase land for a church. Where to build was the question. Port Richmond, the center of activity, had many Greeks, but the farmers outnumbered them. They purchased land at 1641 Richmond Avenue, in Bulls Head. It was a convenient choice because the last stop of the trolley from Port Richmond Square was Bulls Head. In January 1930, they prepared to begin construction. On Sunday, May 4, 1930, the cornerstone ceremony was held with a solemn blessing by Metropolitan Panteleimon of Jerusalem. On May 25, 1930, *thyranixia*, which means the opening of the doors, was celebrated.

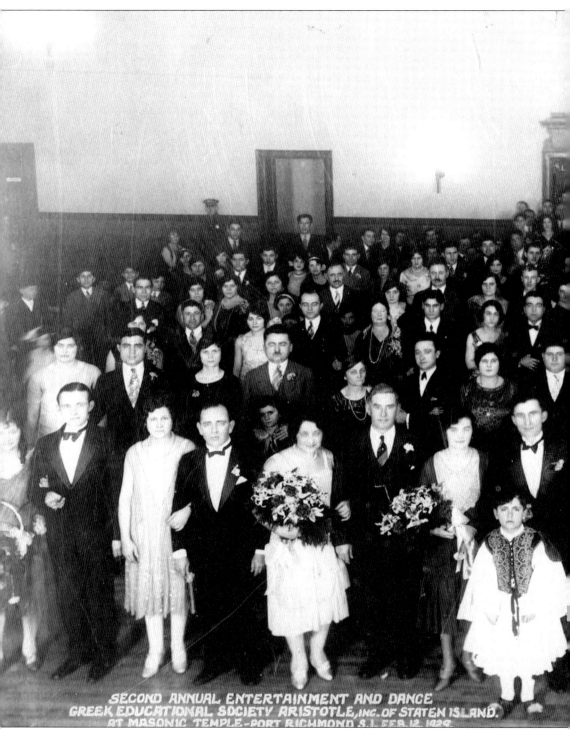

SECOND ANNUAL ENTERTAINMENT AND DANCE
GREEK EDUCATIONAL SOCIETY ARISTOTLE, INC. OF STATEN ISLAND.
AT MASONIC TEMPLE - PORT RICHMOND S.I. FEB. 12, 1929

The Greek Educational Society of Aristotle held its dances at the Masonic temple in Port Richmond. It is safe to say that most, if not all, of Staten Island's early Greek

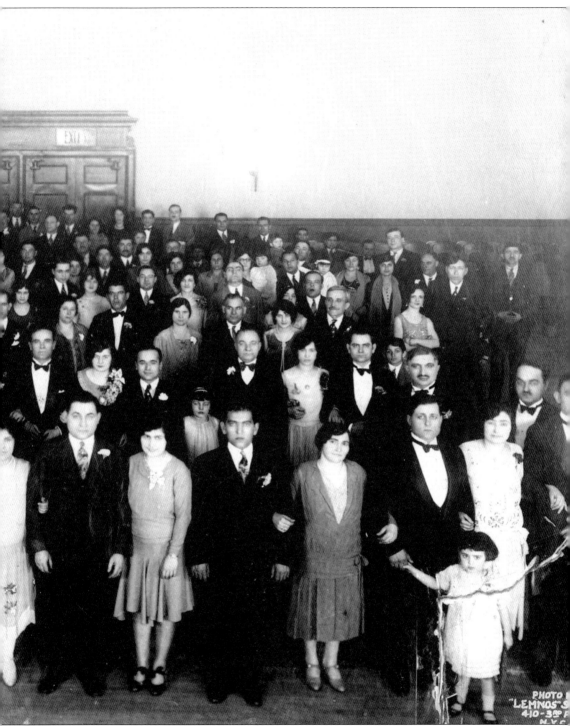

families are represented in this 1929 photograph of its second annual dance. (Courtesy Holy Trinity-St. Nicholas Church.)

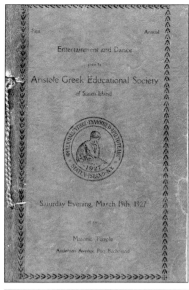

The cover of the first journal is pictured here. In looking through the journal, we recognize the importance of the farmers. There are many advertisements for seeds and other farm necessities. For example "Otto Stumpp Seed Man, New York" advertised along with other seed companies. Makers of wagons like Richmond Wagon Works, "Manufacturer of Auto Body's Wagons and Trucks," Richmond, Staten Island, purchased advertisements. The produce markets also supported the farmers with advertisements such as Ganesvoort Produce Company "Commission Merchants—Horseradish and Carrots our Specialty," with two addresses in New York City. The advertisements for coal attest to the era. It is a look back to the first part of the 20th century. (Courtesy George and Evangeline Katsoris.)

ARISTOTLE GREEK EDUCATIONAL SOCIETY OF STATEN ISLAND

James Catsoris ... Vice-President
Basil Anagnostis ... President
Basil Katsaros ... Treasurer
Charles Sigalos ... Secretary

——o——
AUDITORS
Costas Thanasoulis Nick Skunakis
Costas Alexander

——o——
TRUSTEES
Costas Thanasoulis John Criaris Tony Psomas
Christ Triantafillou

——o——
ARRANGEMENT COMMITTEE
Dimos Exarchos Costas Alexander Spiros Dallas
Costas Thanasoulis James Catsoris
Charles Sigalos Stergios Paximadas

——o——
PUBLICITY COMMITTEE
Dimos Exarchos Tony Chrampanis Costas Thanasoulis

——o——
RECEPTION COMMITTEE
Charles Sigalos, Chairman
Nick Skunakis Costas Thanasoulis
Spiros Dallas Pantellis Paramithis
Christ Triantafillou

——o——
FLOOR COMMITTEE
Spiros Dallas Nick Skunakis Erafim Teligadas

——o——
FLOWER COMMITTEE
Mrs. Rodo. Triantafillou
Miss Mary Katsarou Miss Cleopatra Polychroni
Miss Ioanna Katsarou Miss Katherin Psomas
Miss Stauroula Kaleri Miss Helen Awagnostov
Miss Catherine Xypoulea

ORDER OF DANCES

PART I.
GRAND ENTREE NATIONAL HYMNS
1. FOX TROT—My heart will tell you so By Remick
2. FOX TROT—Hello bluebird By Remick
3. FOX TROT—Black bottom By Harms
4. WALTZ—Charlie I love you By Harms
5. FOX TROT—Bye bye blackbird By Remick
6. FOX TROT—Baby face By Remick
7. FOX TROT—Lucky Day By Harms
8. WALTZ—Athens Beauties By Vasilatos
9. FOX TROT—I'm on my way home By Berling
10. FOX TROT—Kantinka By Feist
11. FOX TROT—Birth of blues By Harms
12. WALTZ—Ahela Waltz By Vasilates

GRAND MARCH BY GREEK COMMUNITY
OF STATEN ISLAND, N. Y.

PART II.
1. ONE STEP—Trive trive Arr. By Vasilatos
2. FOX TROT—Who'll be the one By Berling
3. FOX TROT—Petuska By Waterson
4. WALTZ—A Little Spanish town By Feist
5. FOX TROT—How I love you By Berling
6. FOX TROT—Half moon By Chapiro
7. TANGO—Santa Lussia By Vasilatos
8. WALTZ—Falling in love with youBy Harms
9. FOX TROT—Thinking of you By Feist
10. FOX TROT—The Word ove By Andrison
11. FOX TROT—Arabia Dream By Andrison
12. GREEK NATIONAL DANCES By E. Vasilatos

——o——

MUSIC by EVANGELOS VASILATOS
and his
SOCIETY ORCHESTRA

Tel. Longacre 3426 418 W. 46th Street
NEW YORK CITY

The journal included the order of dances. The music was planned ahead of time and publicized. The Fox Trot, the Waltz, the One Step, and the Tango are listed in the program. No dance would be complete without the Greek national dances mentioned at the end, since regional Greek dances are very important to Greek people. The journal also lists the officers of the Aristotle Society. The names are familiar to Staten Islanders since they are the founders of the church. (Courtesy George and Evangeline Katsoris.)

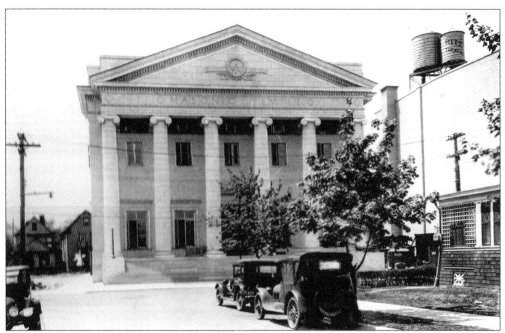

Look at the Greek architecture of the magnificent Masonic temple in Port Richmond. The inside was just as beautiful. When the Aristotle Society held its annual dances here, they must have felt like they were visiting the temples in Greece—a perfect setting. (Courtesy Staten Island Historical Society.)

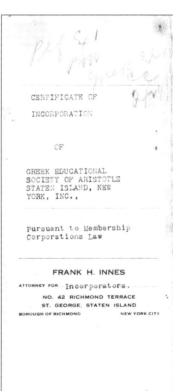

CERTIFICATE OF

INCORPORATION

OF

GREEK EDUCATIONAL
SOCIETY OF ARISTOTLE
STATEN ISLAND, NEW
YORK, INC.,

Pursuant to Membership
Corporations Law

FRANK H. INNES

ATTORNEY FOR Incorporators.

NO. 42 RICHMOND TERRACE
ST. GEORGE, STATEN ISLAND
BOROUGH OF RICHMOND NEW YORK CITY

Demetrios Plasteras, a Greek school teacher, convinced the families to formalize their group by incorporating the Aristotle Society. The cover page of the incorporation papers is shown. Twelve men signed the papers: Basil Anagnostis, James Katsoris, Emanuel Katsoris, John Bakalis, Stratis Skunakis, Nicholas Skunakis, Costas Thanasoulis, Costas Touloubos, Anthony Chrampanis, Seraphim Telegadas, Costas Caffentzis, and Nicholas Caffentzis (names used as spelled on the papers). (Courtesy Holy Trinity-St. Nicholas Church.)

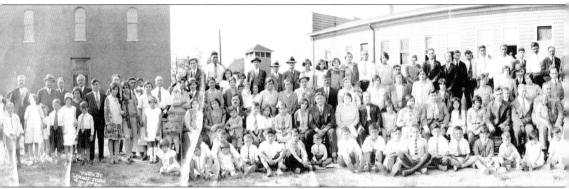

The Aristotle Society held a picnic at St. Adalbert's Park in Elm Park on September 15, 1929. In this photograph you can see how the families have grown to include many

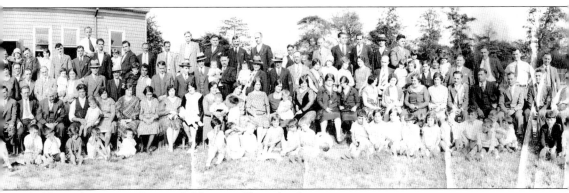

children. (Courtesy Gus and Olympia Skunakis.)

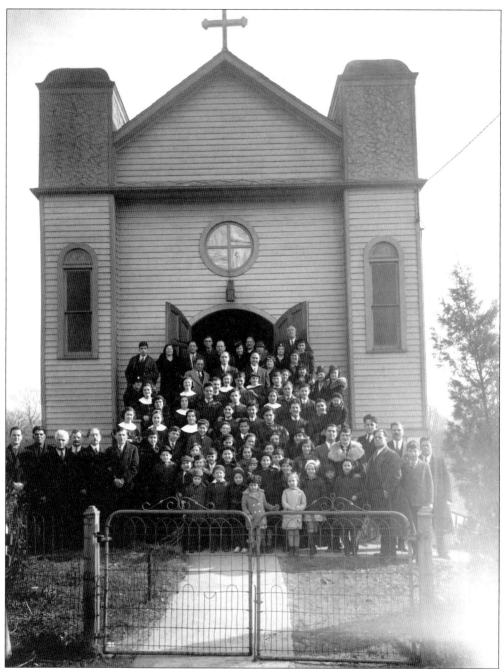

The community gathers around the choir on the steps of Holy Trinity Church when it was at 1641 Richmond Avenue. The little girl being held aloft by her cousin, James Condaxis, on the right side of the picture is Mary Parathiras Veros, now a long time member of the choir. This photograph shows the church as originally built, before any additions were made. (Courtesy Mary Veros and Holy Trinity-St. Nicholas Church.)

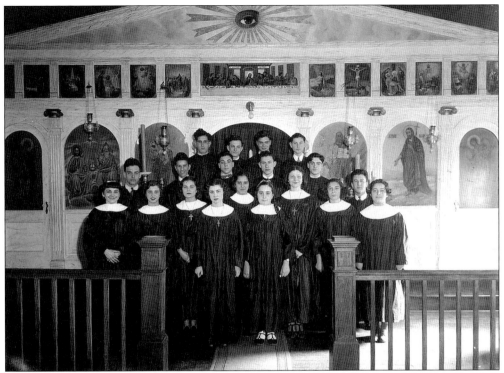

This early photograph of the choir shows great detail of the original church. Note especially the icons above the doors leading into the altar. This was probably taken the same day as the cover photograph. (Courtesy Eugenia Psomas.)

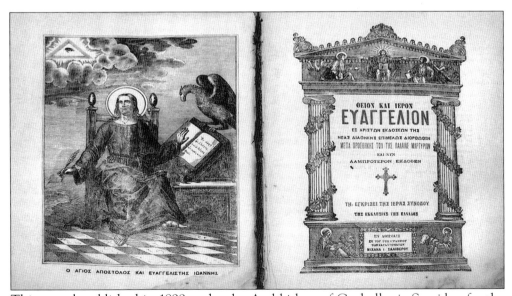

This gospel, published in 1899 under the Archbishop of Cephallonia Spyridon for the Holy Synod of the Church of Greece, was used during liturgy (mass) in the early years of the Holy Trinity-St. Nicholas Church. (Courtesy Holy Trinity-St. Nicholas Church.)

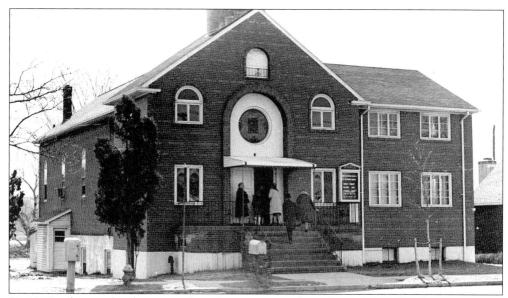

By 1949, adjacent land was purchased to accommodate the growing Greek community. The original church had been built quickly with the help of the farmers' wagons carting supplies to the site. This time the farmers used their trucks to pour more than 100 truck loads of dirt on the site, which was below street level. The whole parish joined in the effort. By 1955, a new wing was added. (Courtesy Holy Trinity-St. Nicholas Church.)

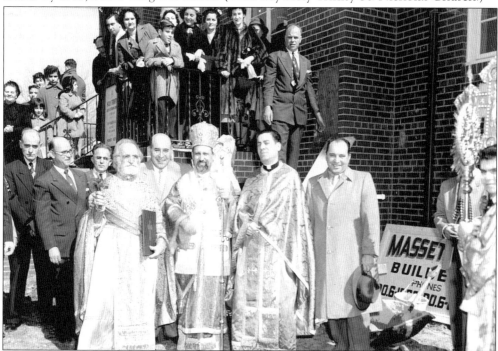

On Sunday, March 13, 1955, the cornerstone-laying ceremony was held. Bishop Demetrios of Olympos officiated, assisted by Frs. John Aslanides, Vasileos Papanikas, C. Souliopoulos, and Andrew Vasilas, the host pastor. Borough president Albert Maniscalco attended. (Courtesy Holy Trinity-St. Nicholas Church.)

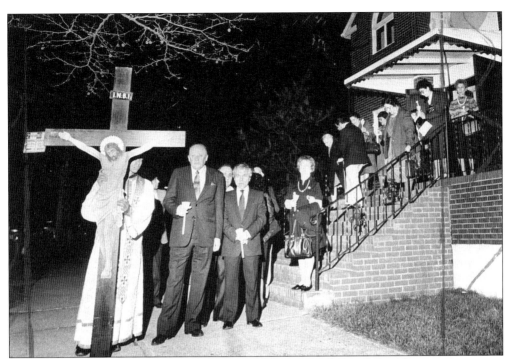

Congregants follow the cross from the steps of the original church building in an evening service. (Courtesy George and Evangeline Katsoris.)

With the opening of the Verrazano Bridge, the parish experienced new growth. They hired a full time priest, Fr. Spyridon Macris. He realized that a bigger church would soon be needed, so land was purchased on Victory Boulevard adjacent to the property. This photograph shows borough president Robert O'Conner lifting the first shovelful of dirt at the groundbreaking ceremony in June 1967, as Fr. Macris and parishioners watch. (Courtesy George Garis.)

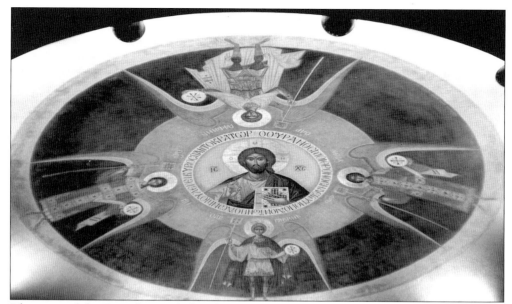

The icon of the Pantokrator (Almighty) is painted in the dome of the church to show that Jesus is always watching over us. The archangels Michael, Gabriel, Raphael, and Uriel ring him. Just as the dome always has the Pantokrator, the niche behind the altar always has the Platitera, an icon of the Virgin Mary. (Courtesy Holy Trinity-St. Nicholas Greek Orthodox Church.)

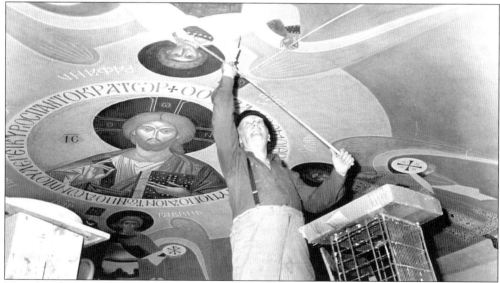

The Greek Orthodox Church does not have three dimensional statues. The icons that adorn the walls and ceilings of a church are much more than decorations. They are teaching vehicles of Orthodoxy. In a time when people could not read, they saw the picture, the priest explained the picture, and they knew the story of the event or the saint depicted. Therefore, choosing the iconographer for a new church is extremely important. In 1972, the church commissioned Alexandru Mazilescu, a renowned Roumanian-Greek artist, to paint its icons. He is shown painting the dome of the new church. (Courtesy Holy Trinity-St. Nicholas Greek Orthodox Church.)

Once a new church was constructed, the dream of a new community center was conceived. In order to make the dream a reality, the original church building was torn down on March 28, 1996. This photograph shows Fr. Nick Petropoulakos and parish president Mike Anastos carrying the cross which sat atop the old church and community center prior to demolition. The cross now hangs in the lobby of the new community center. (Courtesy Holy Trinity-St. Nicholas Church.)

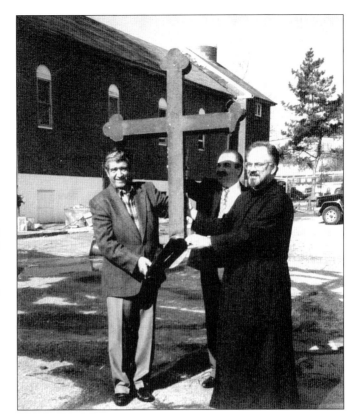

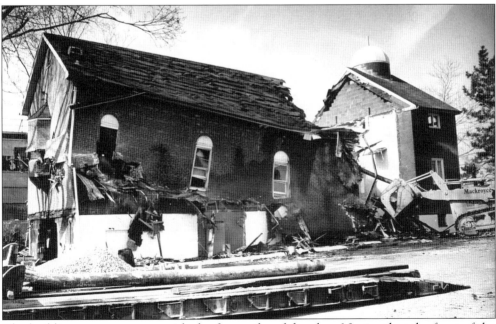

The building was torn apart with the first strike of the claw. Notice that the front of the original church building was left intact. (Courtesy Holy Trinity-St. Nicholas Church.)

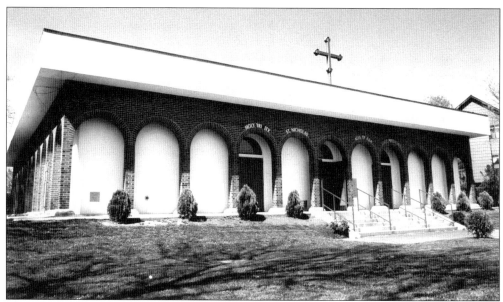

This is the church as it stands today overlooking Victory Boulevard. Parish priests were: Rev. Theodore Anagnostiades, 1930–1932; Rev. Vasilios Papanikas, 1932–1934; Rev. John Aslanides, 1934–1937; Rev. Emilianos Pashalakis, 1938–1938; Rev. Dimitrios Callimachos, 1938–1949; Rev. Demetrios Heliopoulos, 1949–1950; Rev. Andrew Vasilakopoulos, 1950–1955; Rev. Christos Pappas, 1955–1964; Rev. Spyridon Macris, 1965–1989; Rev. Nicholas Anctil, 1989–1996; and Rev. Nicholas P. Petropoulakos, 1996–present. (Courtesy Holy Trinity-St. Nicholas Church.)

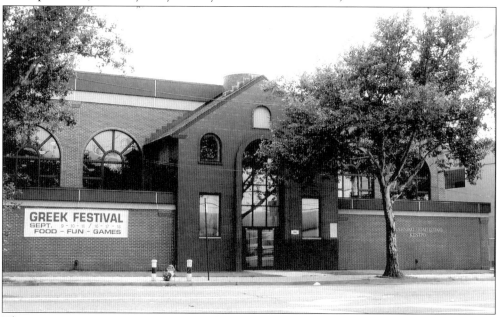

The new community center sits on the site of the original church. Planners felt that they wanted to keep the front of the original church building, so it was incorporated in the new design for the community center which opened in 2001. (Courtesy Christine Charitis.)

Five

A Year in the Life of the Greeks

In worship, the communal bonds of faith and love give us strength and joy.
—His Eminence Archbishop Demetrios of America,
Orthodox Observer, July–August 2004

In every group, whether ethnic, religious, or other, there are special celebrations and observances. The Greek community of Staten Island is no different. Since 1971, Staten Islanders have been part of the ongoing celebration of Greek culture, the annual festival. Every September thousands of people join in for souvlaki, gyros, pastitsio, spanakopita, moussaka, roasted lamb, chicken with rice, Greek salad, olives, and feta cheese. They watch costumed Hellenic dancers perform line dances from various parts of Greece and listen to the wailing, soulful, beautiful music performed by live bands. Everyone becomes one, sharing the joy of the occasion and the Greek culture. Some even join in on the dance line. They feel that they know what it is to be Greek, but this is only one aspect of the Greek community.

Greeks have a unique way of celebrating everything, whether it is religious or secular. For example, look at some religious ceremonies starting with the birth of a baby. When the baby is 40-days-old, he or she is churched. The priest brings the baby to the altar, inside the altar if the baby is male. When the baby is older, he or she is baptized. The Greek Orthodox baptism involves full immersion of the baby. At a wedding, the bride and groom wear crowns which are crossed in a ritual by the best man. The bride and groom take on a spiritual responsibility in marriage, so they receive crowns like the great champions of faith.

The celebration of Easter differs from that of other major faiths. Easter is calculated using a Julian calendar. On Holy Friday, Greeks walk under the *kouvouklion* (the tomb of Christ). On Easter, Greeks each bring home a candle which has been lit in church by a single flame. One of the manmade traditions is to celebrate epiphany by diving for the cross after the waters are blessed. Greeks celebrate St. Basil's Day instead of New Year's Day on January 1 by baking a *vasilopita* and putting a gold coin in it for luck.

On the secular side, Greek Independence Day is celebrated with a parade in Manhattan and a presentation, in Greek, by the Greek school. Children, from a very young age, wear costumes from their ancestors' region in Greece. They learn the regional dances by the time they are teenagers. There are many of what Fr. Nick Petropoulakos calls *Yiayiologies*, such as the admonition that "when you leave someone's house, you must go out from the same door that you entered." Whether it be the religious rituals, the food, or the secular celebrations, the Greeks have gained strength from within their community and have strengthened external bonds with the community at large by sharing their heritage and culture.

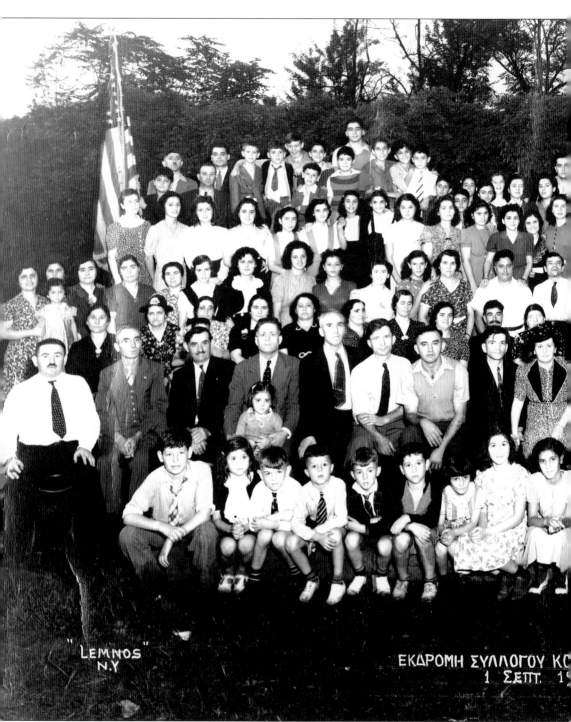

"LEMNOS"
N.Y.

ΕΚΔΡΟΜΗ ΣΥΛΛΟΓΟΥ ΚΟ
1 ΣΕΠΤ. 1

This picnic, held in a park near St. Adalbert's Church on Morningstar Road in 1940, offers a glimpse into the Americanized face of the Greek immigrant families. The families who came from the island of Lemnos retained their ties with other "Lemnians," gathering yearly for a picnic. The dual flags of America and Greece show the dual nature

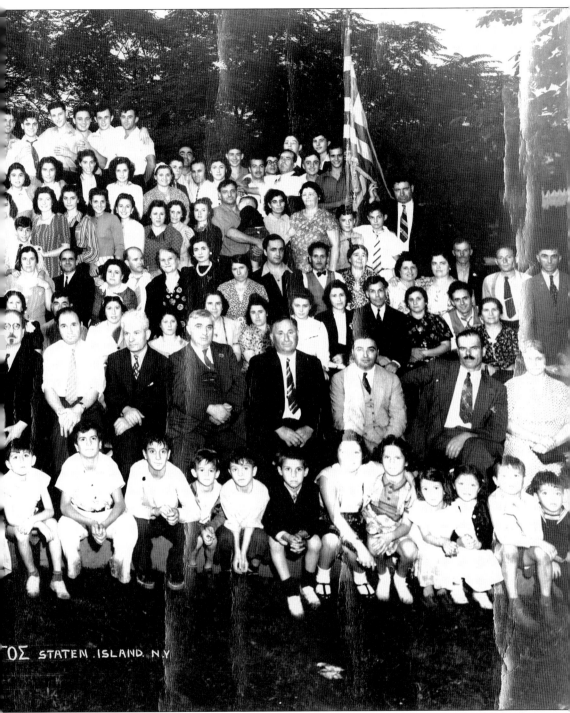

ΟΣ STATEN ISLAND. N.Y.

and pride of these immigrant families. The Greek caption means "Outing of the Club of the Church, September 1, 1940." At least 75 of the people in this photograph have been identified, many of whose stories are highlighted in this book. (Courtesy Holy Trinity-St. Nicholas Greek Church.)

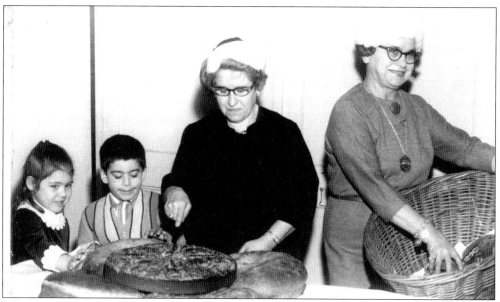

January 1 is St. Basil's Day. The Greeks start the new year with a special bread called *vasilopita* or Basil's pie. The person who receives the gold coin baked inside is supposed to have good luck in the coming year. In church each organization and each person gets a slice of bread, and money is collected for St. Basil's Academy in Garrison, New York. At home, some families cut the bread at midnight, New Year's Eve. At the Mardikos house, Thessalia used to leave the house by the back door and enter by the front door carrying a bottle of milk and a jar of honey. She would enter the front door right foot first saying "May the rest of the year be filled with milk and honey." Pictured here from left to right are Angela Sigalos, Anthony Psomas, Katherine Trivelas, and Thessalia Mardikos. (Courtesy Ladies Philoptochos Society.)

A-10 Honolulu Star-Bulletin Monday, Jan. 6, 1969

Water blessing was a wet rite

By Judy Chase
Star-Bulletin Writer

Honolulu's first Greek Orthodox water-blessing ceremony was unique in that everyone, attending got soaking wet.

At the end of a special Epiphany service at the Waikiki Natatorium yesterday, the Rev. T. Dean Gigicos threw a wooden cross into the Natatorium pool, after which seven young men dived for it.

Peter Christoflakes, a sophomore at New York's Staten Island Community College who is visiting his uncle John J. Johnson of Honolulu, retrieved the cross. According to Greek Orthodox tradition, the retriever is supposed to have good luck throughout the year.

But by the time the Rev. Mr. Gigicos was ready to throw the cross, getting wet was no big thing. He was halfway through the liturgy, when a heavy downpour drenched everyone.

A CROWD OF some 250 church members and their guests was watered down to about 30 — the Rev. Mr. Gigicos, a persevering choir and a few of others. Everyone else took shelter under the Natatorium bleachers.

Then, just in time for the special blessing, the sun came out bringing the rest of the congregation with it.

Baptizing the cross, as the ceremony is called, is a Greek Orthodox tradition dating back to the 4th Century, when the ocean was blessed each year so that it would be safe for the seafaring Mediterranean people, Mr. Gigicos said.

The same ceremony today symbolizes death when the cross is thrown and ressurection when it is retrieved, he said.

"As a whole, the ceremony is a reminder of the church's doctrine of everlasting life," Mr. Gigicos said.

The Epiphany, the 12th day after Christmas, commemorates the day Jesus Christ was baptized to members of the Eastern Orthodox Church, he said. It was on the Epiphany that the Trinity was revealed for the first time.

Mr. Gigicos said the water-blessing ceremony is held outdoors mostly in places where the weather is warm. However, Christofilakes said his church in New York does hold the ceremony outdoors on the Epiphany. "it's pretty hard to make yourself dive in there, water is near freezing."

RETRIEVING THE CROSS — Peter Christofilakes retrieves the baptized cross, then swims back for a special blessing.

On Epiphany, the 12th day after Christmas, there is a special blessing of the water, commemorating the day Jesus was baptized. If a church is near water, the priest will throw a cross into the water, and a group of young men will try to retrieve it. Peter Christofilakes was the lucky one to retrieve the cross when he visited his uncle in Honolulu, Hawaii, on January 6, 1969. (Courtesy Peter Christofilakes)

82

Joanne Vlastakis lit a candle upon entering the church at Christmastime in 1981. Greeks light a candle whenever they enter church. It is symbolic of the Old Testament Gifts to the Temple which were purchased and burned for that use. Greeks give a donation for the candle signifying the purchase of that gift. (Courtesy Paul Vlastakis.)

Harry Papasavas receives communion from Archbishop Demetrios and Deacon Nektarios Morrow when the archbishop visited Staten Island. (Courtesy Staten Island Advance; photographer Joshua Carp.)

Each year, parishioners make at least 1,000 palm crosses for Palm Sunday. Altar boys John Poulmentis (left) and James Rassias are bringing the crosses for the priest to distribute at the end of the liturgy. (Courtesy George Garis.)

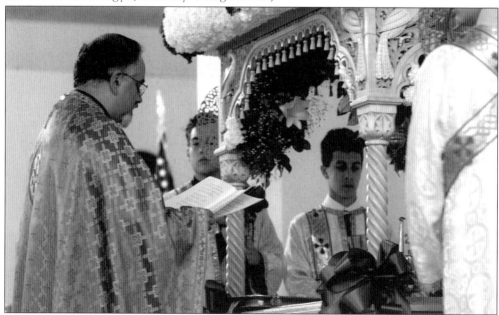

Fr. Nicholas Petropoulakos is blessing the *Kouvouklion*, the tomb of Christ in which an embroidered icon of the deceased Christ has been placed. The current tradition is for the *Kouvouklion* to be carried outside and around the church and for the parishioners to pass under it to reenter the church. The true tradition was to carry just the icon of the deceased Christ. Altar boys Dimitri Sidiropoulos (left) and Stephen Stark assist Fr. Nick Petropoulakos. (Courtesy Staten Island Advance; photographer Michael McWeeney.)

In Orthodox tradition a baby is kept at home for 40 days, and the first place his parents take him is church. At the end of liturgy (mass), the priest brings the baby up to the front of the church for a blessing. Boys are brought inside the altar; girls are not. Fr. Nick Petropoulakos is "churching" Michael Shane Bonner, son of Gerard and Lea Bonner. (Courtesy Gerard and Lea Bonner.)

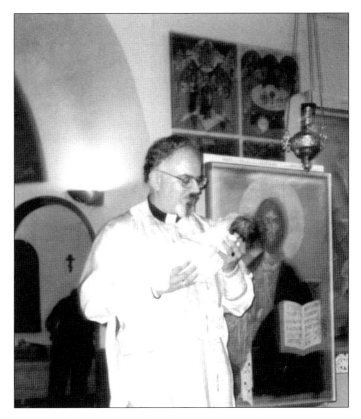

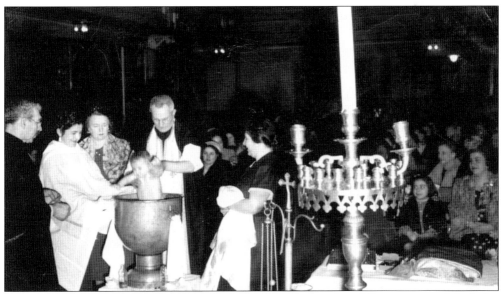

Bapto means to dip or immerse, so the Orthodox baptism involves full immersion of the baby. Baptism is a religious rite of initiation by which a person enters the Christian community. Catherine Johanides is being baptized here in 1948. (Courtesy Madeline Johanides.)

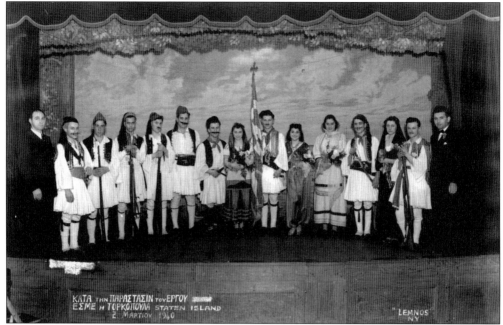

There is nothing like a Greek play to celebrate Greek Independence Day. On March 2, 1940, the play "Esme the Turkish Girl," was presented at a church dance. The lead players were Helen Condaxis and John Parathiras. Greek school teacher, Mr. Lazarous is on the right, Neoclis Parathiras is on the left. (Courtesy Holy Trinity-St. Nicholas Church.)

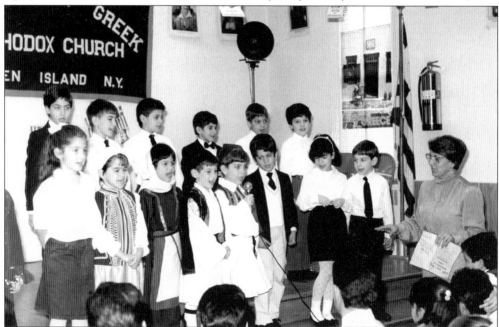

The afternoon Greek school is seen performing a play about Greek Independence Day. Seen at the right is Emily Antonopoulos, who has been the afternoon Greek School teacher for the past 28 years. Not pictured is Voula Grammatikopoulos, who has taught for 10 years. (Courtesy Emily Antonopoulos.)

Every year a beautiful, talented, and knowledgeable young Greek woman is chosen to be Miss Greek Independence. Catherine Vissarites, shown here with District Greek Orthodox Youth of America chairman John Charitis, was Miss Greek Independence in 1967. She represented Three Hierarchs Greek Orthodox Youth of America. They are both active in the church today. Catherine has used her vocal talents as choir director for many years. John has been involved in the business end as board member, festival and journal chairman. (Courtesy Catherine Kalaizes.)

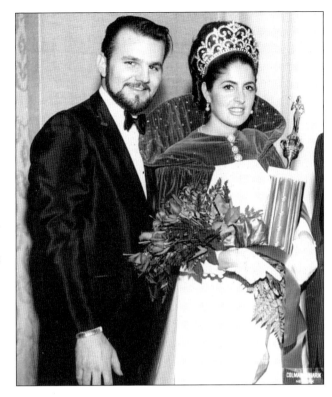

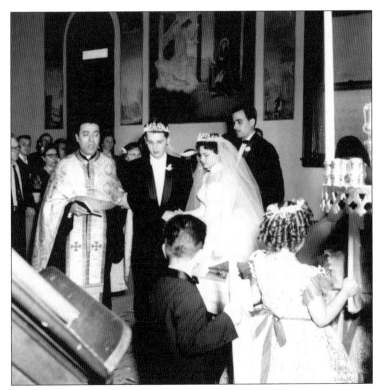

This photograph is from the wedding of Aristarhis Veros and Mary Parathiras on May 15, 1955. They are wearing the crowns of marriage, symbolizing that they are rulers of their new home together. Their reception was held at one of the favorite catering halls of old, Tavern on the Green. It later became the Shalimar. Now it is the Excelsior Grand. (Courtesy Mary Veros.)

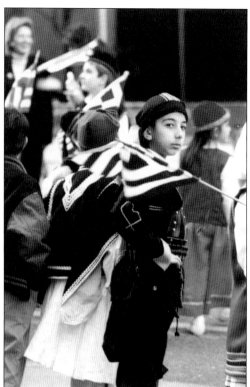

Dimitri Grammatikopoulos is dressed like a soldier from Pontos for the Greek Independence Parade on Fifth Avenue. (Courtesy Holy Trinity-St. Nicholas Church.)

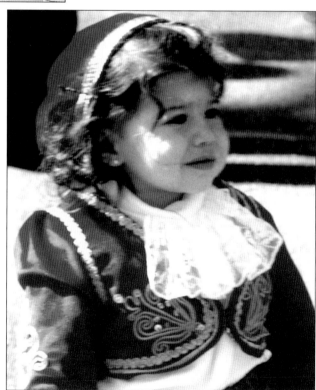

Eleni Alexandra Trepel, only 18 months old, was already dressed in Greek costume for the parade. (Courtesy George and Panayiota Karidis.)

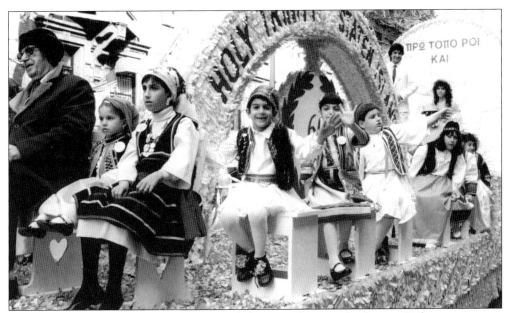

Holy Trinity-St. Nicholas had a special float in the parade for its 60th anniversary. Seated on the float from left to right are ? Pappas, Stephanie Karidis, Tina Marie Vlitas, George Kalaizes, Nicole Litos, Nicholas Mousmoutis, Maria Lucas, Irene Alysandratos, Jack Sheherlis, and Cynthia Skunakis. (Courtesy George and Panayiota Karidis.)

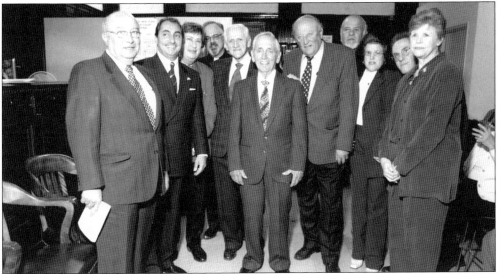

Assemblyman Matthew Mirones, who serves the 60th district, has revived the Borough Hall Tribute to Greek Americans on the occasion of Greek Independence Day. Attending the 2003 celebration were, from left to right, Borough president James Molinaro, assemblyman Matthew Mirones, and the honorees; Mary Chrampanis, Rev. Nicholas Petropoulakos, Peter Katsoris, Louis Chrampanis, George Katsoris, and Gus, Vanessa, Michael, and Marlene Petrides. Honorees in 2004 were Stacy Anastos, Dimitri Karelas (posthumously), Jim Sidiropoulos, and John Plevritis. Honorees in 2005 were George Garis, Tessie Kindos, Peter Psomas, and Chrisanthy Skunakis (posthumously). (Courtesy Staten Island Advance; photographer Jin Lee.)

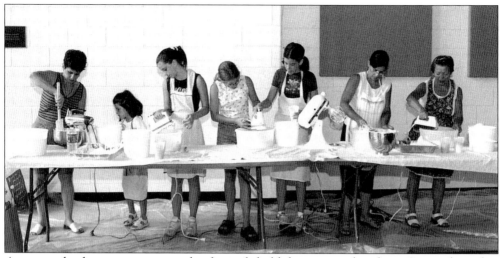

Anyone who has ever come to the festival, held for two weekends in September after Labor Day, knows how delicious those cookies are. Each year parishioners bake the koulourakia, kourambiedes, and ravani just before the festival. Pictured from left to right are Mary Kusas, Emily Cummings, Allison Mireau, Catherine Cummings, Christine Mireau, Chrysoula Koulouris, and Elizabeth Papas. (Courtesy Staten Island Advance; photographer Jan Somma.)

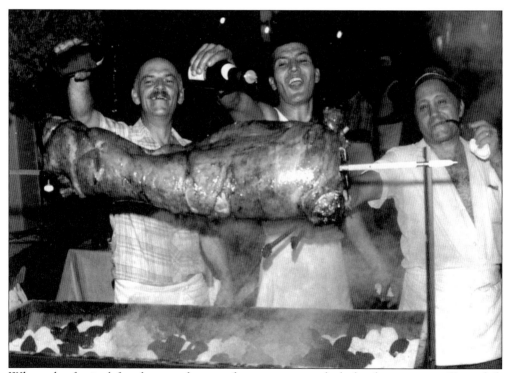

When the festival first began, they used to roast two whole lambs on a spit. From left to right, George Matheos, Paul Vlastakis, and Peter Triantafillou are pouring wine over this lamb at the 1983 festival. (Courtesy Paul Vlastakis.)

When Fr. Nicholas Petropoulakos came to New York in 1996, Mayor Rudy Giuliani gave him a New York welcome at the annual festival. (Courtesy Holy Trinity-St. Nicholas Church.)

Ah, the melodious music of the Litos Brothers. For years, Islanders have enjoyed their music at the festival. From left to right, Louis Germanakos, George Litos, George Xouris, and Andrew Litos are performing in front of a mural painted by Linda Gerecitano and friends. (Courtesy George and Pat Litos.)

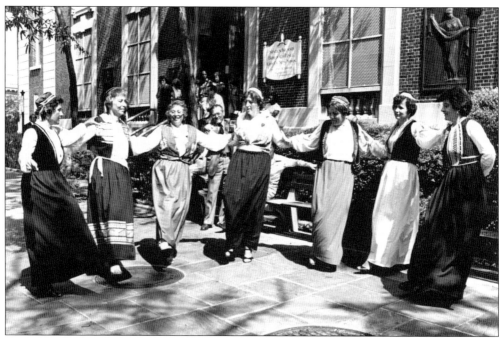

A group of ladies dance at Borough Hall to get people in the mood for the Greek festival in 1979. From left to right are unidentified, Evangeline Katsoris, Artemis Sakoutis, Emily Panagakos, Anne Macris, Aliki Scarpelos, and Marina Nicolaides. (Courtesy George and Evangeline Katsoris.)

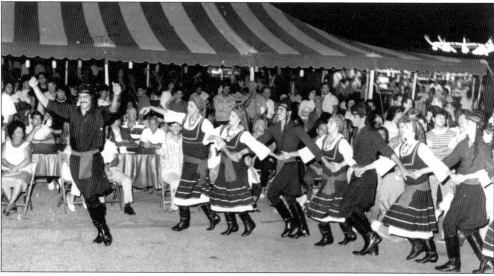

Much to the delight of onlookers, the Holy Trinity Hellenic Dancers have performed at the festivals for years. From left to right, Jim Chukalas, Pauline Anastos, Donna Harros, Tom Vlastakis, Tammy Papanikolaou, Jack Sheherlis, Helen Coussoule, and Anthony Panagakos were performing one of the regional line dances in this 1988 photograph. Some of the most popular dances are the Tsifteteli, the Kalamatiano, the Sousta, and of course, the Syrtaki, (Sailors' Dance) also known as Zorba's Dance. The dancers were trained by Catherine and Edward Haliotis. (Courtesy Christina Chukalas.)

Six

ORGANIZATIONS
OF THE PARISH

To properly define Hellenism one would need a scholar to explain its origins, an artist to draw on its beauty, a poet to describe its heart, and a theologian to explore its soul. Simply put, Hellenism is the basis for man's humanity to his fellow man.
—Johnny N. Economy, Past Supreme President, *the AHEPAN Winter 2005*

The Greek Orthodox Church in America is a mix of hierarchy and democracy. The religious aspect is headed by the priests, the bishops, the archbishops, and the patriarch. Coordinating the business and secular aspects of the churches are many organizations, starting with an elected Parish Council.

As explained earlier, the first Greek organization on Staten Island was the Greek Educational Society of Aristotle, Incorporated. In 1927, 12 directors signed the incorporation papers with the stated goals of providing a meeting place for social activities and the promotion of good fellowship and good citizenship among its members and their families. Its unstated goals were to keep the Greek language and culture alive.

Once Holy Trinity Church opened in 1930, the religious needs were met, but the need for other organizations arose. An afternoon class or Saturday Greek school was, of course, a necessity. At one point, there was such an interest in learning the Greek language that classes were also taught at St. Alban's Church. Today, the afternoon Greek school covers grades one through seven, with a Regents class following grade seven.

The Great Depression caused hardship all over the country, so a national philanthropic organization, the Greek Orthodox Ladies Philoptochos Society, was established in 1931 throughout the Archdiocese. Every church was asked to form a Philoptochos (friend of the poor) chapter. The Staten Island chapter continues its philanthropic efforts to this day.

Through the years, other organizations have existed within the church. The Sunday school has classes from prekindergarten to teens. The Parent Teacher Organization (PTO) was formed to enhance the Greek school and Sunday school programs. The Greek Orthodox Youth of America (GOYA) and the Junior Orthodox Youth (JOY) were formed to keep the teens and young adults active and give them a social outlet within the church as well as with other area churches.

The American Hellenic Educational Progressive Association (AHEPA) is a national organization founded in 1922 in response to the bigotry that emerged in the early 1920s and to help Greek immigrants assimilate into society. AHEPA and the Daughters of Penelope, (founded in 1929 as the women's affiliate of AHEPA) have been, and remain, an active part of church life.

Current programs for the youth include: the Girl Scouts, Daisies through Seniors; the Holy Trinity Soccer Club; and the Holy Trinity Hellenic Dancers. The Golden Years Seniors is a popular meeting place for seniors citizens, both Greek and non-Greek. Recently, the Cretan Society has formed in response to the growing number of Greeks in the parish from the island of Crete. The Staten Island Greek community is still evolving today.

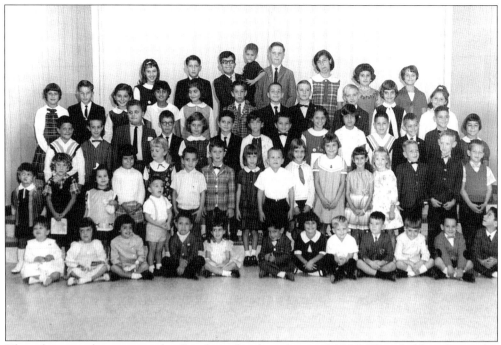

This photograph contains the Sunday school students of 1966. The children leave the liturgy to attend classes which cover nursery school to eighth grade. (Courtesy Holy Trinity-St. Nicholas Church.)

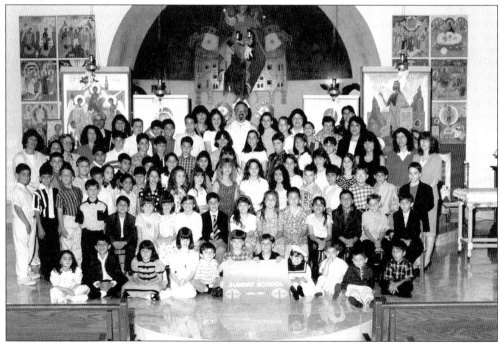

Fr. Nicholas Petropoulakos stands amid the Sunday school teachers and students in this 1996 photograph. Some of the children pictured here are, more than likely, children of those pictured above. (Courtesy John and Christine Charitis.)

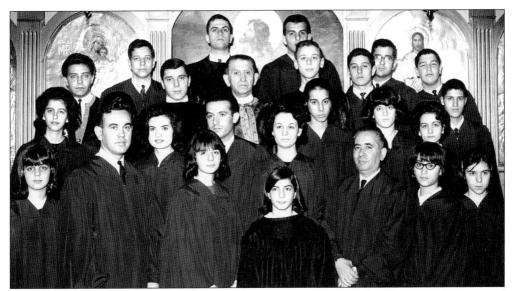

The choir is a very important part of Sunday liturgy by singing the Byzantine hymns and responses. This 1965 photograph shows the priest, Fr. Christos Pappas, surrounded by the choir. From left to right are the following: (first row) Maria Garefalos, Peter Christopoulos (choir director), Magda Garefalos (organist), Diana Constant, Thomas Kouloulis (chanter), Angie Callas, and Theodora Genetos; (second row) Georgia Chrampanis, Stella Skunakis, Nick Itsines, Penny Itsines, Patty Cass, Cathy Psomas, Connie Itsines, and Tommy Kindos; (third row) George Athas, Peter Kanakaris, Chris Zazakos, Rev. Christos Pappas, Tommy Weil, Nick Kartalis, John Pavalis, and Alan Kindos; (fourth row) John Nichols and Peter Christofilakes. Nick Itsines became choir director at a later date. He also wrote the 50 year history of the church in 1977. (Courtesy Peter Christofilakes.)

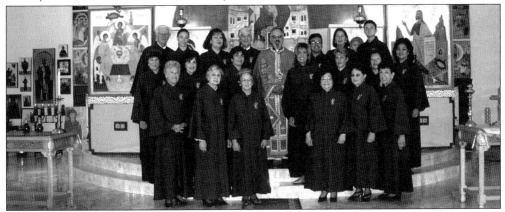

This image shows the choir members of 2002. The choir, led by Catherine Kalaizes, has attended many choir conferences and participated in multi-choral performances on Staten Island and in the metropolitan area. They are currently recording a CD of liturgical music. Pictured from left to right are the following: (first row) Penny Weil, Georgia Psomas, Georgia Jonas, Helen Scozzare, Mary Veros, and Christina Chukalas; (second row) Pat Silas, Anna Borg, Stacy Angelidis, director Catherine Kalaizes, Kathy Tsibros, Elizabeth Papas, and Pat Rassias; (third row) Van Xouris, Ina Imprescia, Bessie Stassinopoulos, Peter Gregor, Rev. Nichols Petropoulakos, Emanuel Stratakis, Mary Mousmoutis, and organist Ken Callaham. (Courtesy Catherine Kalaizes.)

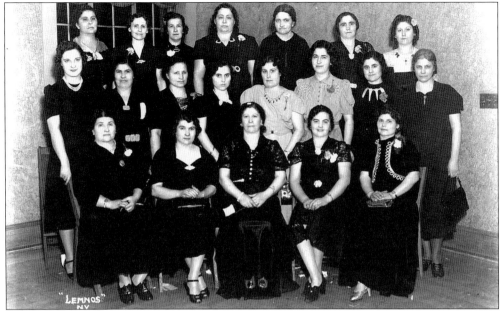

When the Great Depression hit America in 1929, many people needed help. In 1931, the Greek Orthodox Archdiocese responded to this growing need by asking each church to form a Greek Orthodox Ladies Philoptochos Society. Philoptochos translates to friend of the poor. This early image of the Staten Island Philoptochos chapter, taken in 1940, includes wives of the founding families. Today the Philoptochos chapter continues to help. The group cooks for the homeless at the Trinity Lutheran Soup Kitchen. They respond to every emergency, whether it's a national or international disaster, or a family in need. (Courtesy Stella Vlastakis.)

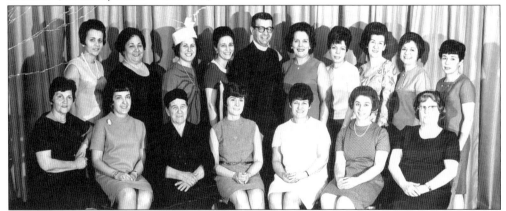

The ladies posed with Fr. Spyridon Macris for this group picture. In 1968, the officers were as follows: president Catherine Cass, first vice president Margaret Garis, second vice president Thassalia Mardikas, recording secretary Basilia Spyridon, corresponding secretary Katherine Fakas, and treasurer Maria Theofanous. In the 1970s, the Staten Island Philoptochos chapter joined with the four Brooklyn chapters of Sts. Constantine and Helen Church, Kimisis tis Theotokou Church, Three Hierarchs Church, and Holy Cross Church to form the Combined Philotopchos Charities of Brooklyn and Staten Island. Through the efforts of their combined luncheons, they have donated approximately $1 million to various charities. (Courtesy Holy Trinity-St. Nicholas Church.)

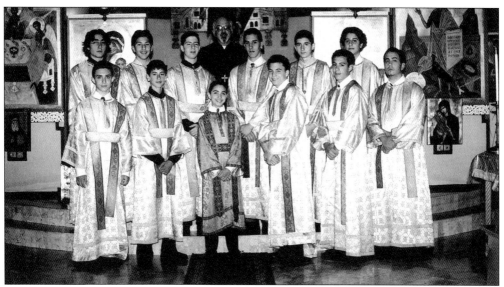

When they reach their teenage years, boys are encouraged to become altar boys. Their purpose is to help the celebrant, in the altar, during services. It is also an opportunity for the young men to learn more about Orthodoxy as they assist the priest. One of our previous altar boys, Peter Zougras, attended Holy Cross Theological School in Brookline, Massachusetts. Pictured in 2004 from left to right are the following: (first row) Nicholas Tamborra, Michael Della Croce, Michael Tamborra, Christopher Dontis, Matthew Tragares, and Robert Callas; (second row) Christos Mavroudis, George Thomas, Louis Papapavlou, Fr. Nicholas Petropoulakos, Stephen Stark, Christopher Kokkinos, and Harry Koulouris. (Courtesy Holy Trinity-St. Nicholas Church.)

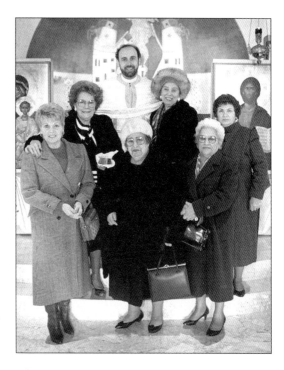

There are many healthy seniors within the community, so a group was formed especially for them in 1987. Pictured here, from left to right, with former priest, Rev. Nicholas Anctil, are Catherine Robustelli, Catherine Cass, Ann Alexander, Mary Teris, Mary Mitchell, and Victoria Vandoros. The Golden Years Seniors, which meets every Tuesday, is not limited to Greeks. Under the planning of Mary Teris, they have enjoyed many trips out and about the town. (Courtesy Mary Tsikteris.)

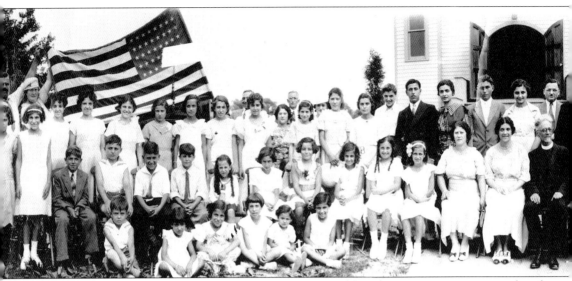

During the mid-1930s, the Greek school was headed by Theano Bouzani. Pictured with Bouzani in the center of the photograph is Fr. John Aslanides. Prior to this, various priests had taught the children Greek lessons. The caption reads, "the Three Greek

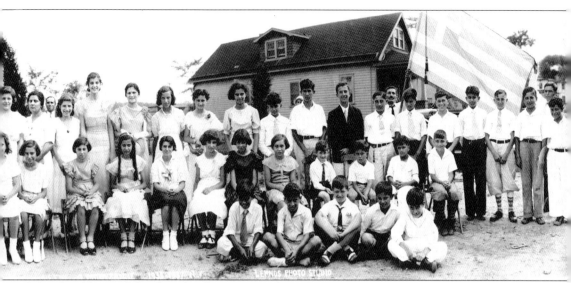

Schools of Staten Island under the Directorship of T. Bouzani." (Courtesy Holy Trinity-
St. Nicholas Greek Orthodox Church.)

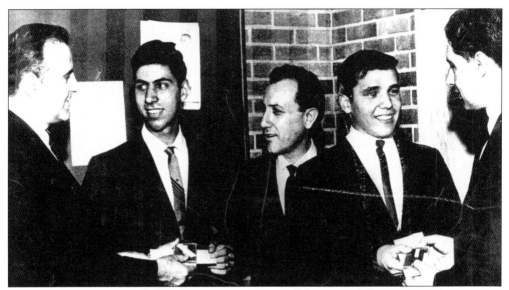

One of the interests of the American Hellenic Educational Progressive Association (AHEPA) is to encourage higher education for Greek Americans. In this photograph dated May 24, 1964, U.S. congressman John M. Murphy (far left) and state senator John J. Marchi (far right) are presenting scholastic achievement awards to John Anagnostis (second from left) and Chris Zazakos (fourth from left) as Michael Constant (center) looks on. The local AHEPA chapter is also called the Michael Constant Chapter of AHEPA because of his long-term work with the association. Senator Marchi's grandmother is from Salonika, Greece. (Courtesy Homer Vandoros.)

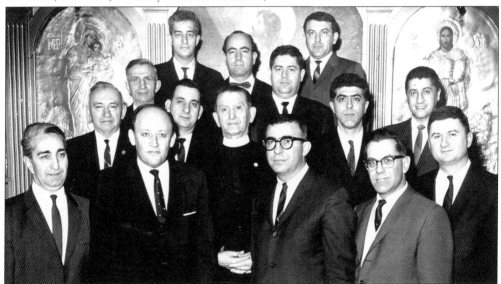

Democracy rules on the secular side of the church. Parish council members are elected. In 1965, the council members, from left to right, were, (first row) Louis Athas, George Katsoris, Peter Spiridon, and Constantine Fakas; (second row) Costas Thanasoulis, James Garefalos, Father Pappas, John Fillou, Harry Apicos, and Thomas Passios; (third row) Dimos Exarchos, Nicholas Filipidis, and Peter Rassias; (fourth row) George Garis and Christ Christon. (Courtesy George and Evangeline Katsoris.)

The Girl Scouts were started in Holy Trinity-St. Nicholas by Anna Mose, Rita Kusas, and Angela Viscione. Christina "Mrs. C" Chukalas and Catherine Kartsonas started the Junior Troop 36 years ago, and as anyone will tell you, Mrs. C is still going strong. This photograph shows the first Gold Award recipients from left to right: Tina Leos, Patricia Gallagher, and Effie Svinos at the ceremony honoring them. The Gold Award is the highest award a girl scout can earn. (Courtesy Christina Chukalas.)

Whether it is Camp Kaufman, Camp Andre Clark, or Camp Inawendewin, the girls love to go camping. This late 1980s tent scene includes, from left to right, (first row) Dora Demoleas, Carla Ghiberti, Sophia Demoleas, Melanie Smith, Joanna Charitis, Tara Lynn Knapp, and Camille Donohue; (second row) Christina Ranieri, Christen Spirocostas, and Heather Johansen. (Courtesy Christine Charitis.)

When his young son, Andreas, had no one to play soccer with, Dr. Demetrios Karelas (left) decided to form a soccer team at the church. Thus in 1990, the Holy Trinity Soccer Club was born. The goal was to provide children an opportunity to gain skills in soccer, to learn good sportsmanship, and to form lasting friendships with the children of the Greek Orthodox community. He recruited fathers as coaches. The club continues today as Dr. Karelas's legacy. He is pictured with Fr. Nicholas Anctil. (Courtesy Fr. Nicholas Anctil.)

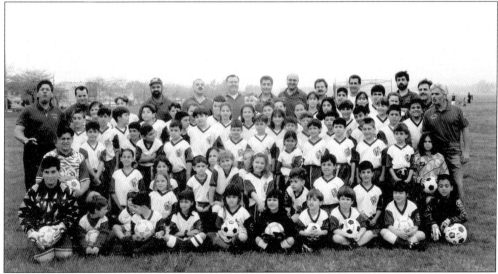

This photograph shows the players and coaches of all of the 1994 soccer teams within the soccer club. Children can play from the age of three until their teens. (Courtesy Christine Charitis.)

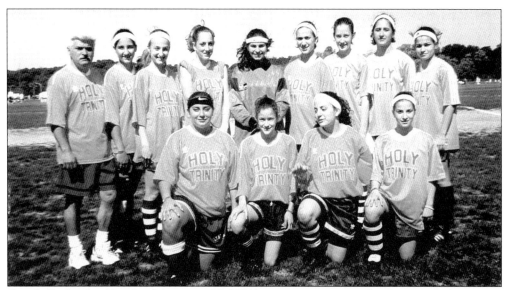

Greek Orthodox Youth of America (GOYA) is an organization for the Greek-American youth. Every church is encouraged to form and retain an active GOYA. They have religious and social events. One important event is the yearly "Olympics" held at Stonybrook University. Goyans come from the metropolitan area to compete in various sports. In 1998, the girls' soccer team won the gold medal. Teammates were, from left to right, the following: (first row) Paris Trataros, Daphne Theodorakis, Sevasti Drossos, and Stephanie Karidis; (second row) coach George Karidis, Angela Antonopoulos, Fotini Antoniadis, Alexis Platis, Krystle Venechanos, Andrea Demoleas, Fotini Theodorakis, Kevi Koulouris, and Maria Karidis. (Courtesy George and Panayiota Karidis.)

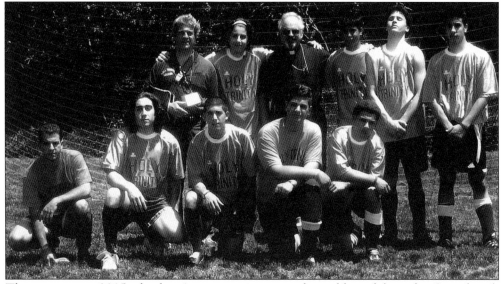

This past year, 2005, the boys' soccer team won the gold medal at the Stonybrook Olympics. Pictured from left to right are (first row) Kostas Bessas, Christos Mavroudis, Vasili Roussopoulos, Angelo Siozios, and Taso Papadopoulos; (second row) coach Costa Papadopoulos, Harry Koulouris, Fr. Nicholas Petropoulakos, Michael Plaitis, Socrates Gramenos, and Stephen Stark. (Courtesy Joanne Kouros.)

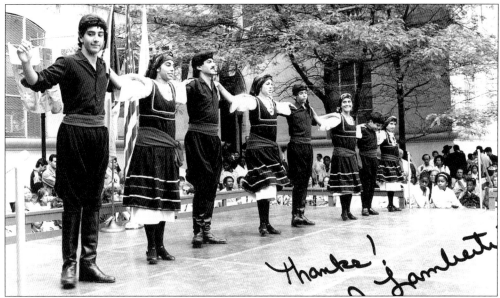

In June of 1987, the Holy Trinity Hellenic Dancers performed at Snug Harbor for a Borough Hall Cultural celebration. They performed all over Staten Island at cultural diversity events. The dancers are wearing Rhodian Jumpers. From left to right, the dancers are Jack Sheherlis, Tammy Papanikolaou, James Chukalas, Cynthia Skunakis, Anthony Panagakos, Helen Vlastakis, Alex Vlastakis, and Tina Marie Vlitas. (Courtesy Christina Chukalas; photographer Chris Johns.)

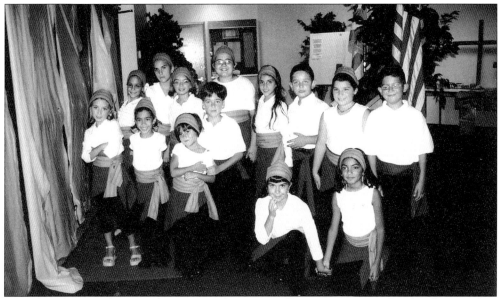

The church recently started a troupe of Junior Hellenic Dancers under the directorship of Susan Katsanos. They performed at the festival for the first time in 2004. From left to right, the dancers are (first row) Ariana Platis, Demetria Thaten, Melina Mitsogiorgakis, Maria Hatsipetros, and Irene Rassias; (second row) Marina Kanakos, Sophia Stark, Anita Platis, Stephanos Mitsogiorgakis, Eleni Katsanos, Kaitlyn Xenakis, Christopher Katsanos, Kayla Vastardis, and George Gregoriou. (Courtesy Petros and Irene Gregoriou.)

Seven

THE AMERICANIZATION OF THE GREEKS

The seed of every action is a thought.
—Ralph Waldo Emerson

Fr. Spiro Macris used Ralph Waldo Emerson's quote in the 1983 Church Journal. He followed it with these words: "As provocative or challenging a thought may be, it requires a person or group of individuals who with their loyal dedication are able to translate a thought into action." This epitomizes the philosophy and, indeed, the actions of Staten Island's early Greek settlers in everything they encountered.

They dreamed of a better life, so they came to America. They needed a church for their families, so, even at the height of the Great Depression, they built one. They were unskilled, so they learned American trades. They worked on the farms and eventually owned some of the best and biggest farms on Staten Island.

They became American citizens; they served in the armed forces. They considered the rights of Americans to be almost sacred. To quote His Eminence Archbishop Demetrios, "Indeed, for the first generation of Greek immigrants, voting on Election Day was treated almost with the respect of a divine commandment." They educated their children. Many farmers' children graduated from college and went on to careers in education, medicine, and business.

Their desire to become American extended to their names being changed. Some changed their names on entry to America. For instance, John Hatzipavlis became John Pavalos while Philip Hatzipavlis became Philip Hatzis. For some the name changed informally, Tsikteris became Teris, Tsagarakis became Garis. For others, like the William Cassolas (Cass) family, a formal change was made which included petitioning the court for a name change and announcing it in the newspapers.

They eagerly embraced America's sports and leisure activities. They were rabid baseball fans. The Psomas boys played with the Staten Island Giants, a minor league team. George Talumbos played Triple-A ball with the New York Yankees (along with Phil Rizzuto). George Katsoris managed the Port Richmond Pirates. The next generation enjoyed basketball as much as their elders did baseball. They spent time at the beach, whenever possible, and danced on the boardwalk along with everyone else. Their annual church picnics and outings always displayed both the American and Greek flags proudly.

The boys might have spoken Greek at home, but they were as American as apple pie in their love for "wheels." John Skunakis had his beloved Thunderbird (white, soft top, red interior). John Anagnostis had his motorcycle. He rode it to Florida. It took him two weeks because it rained every day, so he shipped it back home for $25.

They loved the traditional Greek line dances, but programs for their early annual dances listed the Fox Trot, the Waltz, the One Step, and the Tango, with a single entry for Traditional Greek Dance. They truly enjoyed becoming Americans.

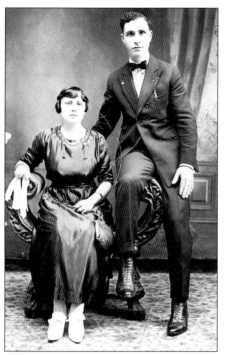

Neoclis Parathiras and Elizabeth Patsis posed for this pre-wedding photograph. They were born in Pergamos, Asia Minor. He came to America in 1912 to escape the Turkish army. He lived in New Jersey at first, where he worked in a tin can factory and a restaurant. He then moved to Pennsylvania and was employed as a coal miner. He worked as a furrier in New York. He sent for Elizabeth in 1920 when she was 21. They married on May 31, 1920, and raised three children, Gus, John, and Mary. Elizabeth worked as a fur finisher for 37 years. She was widowed in 1955. This chain of events was typical for Greek-American families. However, there was a strain of tenacity and a will to succeed in them both. She continued to work after her husband's death and she lived to be 101 years old. (Courtesy Mary Veros.)

Some immigrants come to America and never become citizens. That was not the way for Neoclis and Elizabeth Parathiras. They both became Naturalized Citizens of the United States of America on the same day, June 7, 1940, he at age 46, she at 41. (Courtesy Mary Veros.)

Both Catherine Cass and her husband William were born in America, so their story is different. Catherine was born in Manhattan's Hell's Kitchen in 1923 to Petros and Marianthe Bouhouris, who came from Tseme, Smyrna, in Asia Minor. She attended New York City public schools graduating from Julia Richman High School. She worked as a secretary until she married and started a family. From left to right are Catherine Bouhouris, Catherine Calipolitis, brother Nick Bouhouris, Uncle George Bouhouris (holding Steve Diamondas), Emily Calipolitis (standing), and Gus Diamondas. (Courtesy April Cass.)

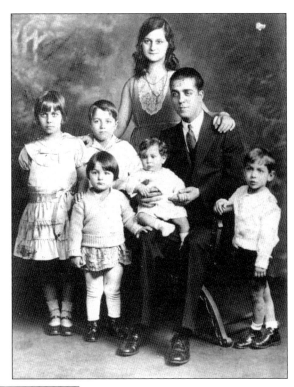

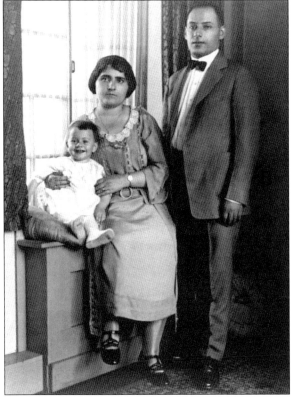

William Cassolas was born in Montclair, New Jersey. His parents, Christe and Polyxeni, had married in Ludlow, Pennsylvania, before moving to New Jersey. He also attended public schools, enlisted in the Navy during World War II, came out and started working for a living. Baby William is being held by his mother in this c. 1923 picture. (Courtesy April Cass.)

Catherine Cass was named an Advance Woman of Achievement by the Staten Island Advance for her work in education. She was a school board chairman, and an assistant for education in Borough Hall during Anthony Gaeta's tenure. She was the first female parish council president at Holy Trinity-St. Nicholas Church as well as a past president of the Ladies Philoptochos Society. She received many awards during her lifetime. In short, she, a first generation American, was able to achieve tremendous success and community respect by living the American life. (Courtesy Staten Island Advance; photographer Robin George.)

William Cass became a very successful businessman and president of Fanning Enterprises, Incorporated. Often people in the business would change their names to Americanize them. This was not an easy matter. Official documents from the William Cassolas family show that notification had to be given in the newspaper after a name change had been granted. William Cassolas and his entire family had to petition for a name change. Daughters April and Melody Cass did not have to change their names because they were born after the change became effective. This document is the petition for name change filed by the Cass family. (Courtesy April Cass.)

Catherine Cass wrote these words on the back of a postcard showing a newsstand on 32nd Street and Third Avenue, "We had franks and soda here on 1st date—into city. 3/43. 'Cheap date,' Bill told me." The couple went from a cheap date at a newsstand to a Frank Lloyd Wright house. They lived the American Dream. (Courtesy April Cass.)

One day, William Cass saw an interview on television. Mike Wallace was interviewing Frank Lloyd Wright. They were discussing some new "prefab" Frank Lloyd Wright homes. William Cass liked what he saw. He told his wife, Catherine, to write to Wright. She did, and they bought a house. Crimson Beech, as it is named, is the only Frank Lloyd Wright House on Staten Island. Everything from the furniture, the design patterns of the curtains, to the color of the paint on the walls had to conform to his plans. The developer, Marshall Erdman, produced several models. The Cass family chose a Usonian with a carport, family room, and board and batten façade. In 1957, the price, unfurnished, was $55,000. With furniture, the price rose to $100,000. (Courtesy April Cass.)

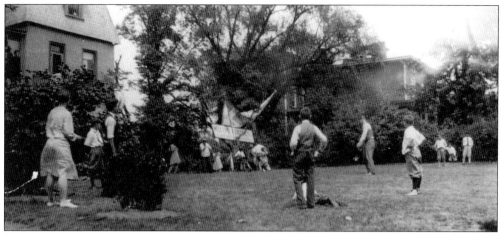

The 22 room house at 33 Mclean Avenue was bought by John Booras, James Kindos's uncle. The house in the back on the right was the original Tennis Club where Mary Outerbridge brought tennis to America. The house on the left, 33 McClean Avenue, was the sister house to 45 McClean Avenue, which is still standing. Jim lived with his Aunt Jenny and Uncle John. For two years, starting when he was 12, James lived alone in the house. This image shows one of the outings John Booras sponsored to bring Manhattan's city children to Staten Island for a day of fun and relaxation. (Courtesy James Kindos.)

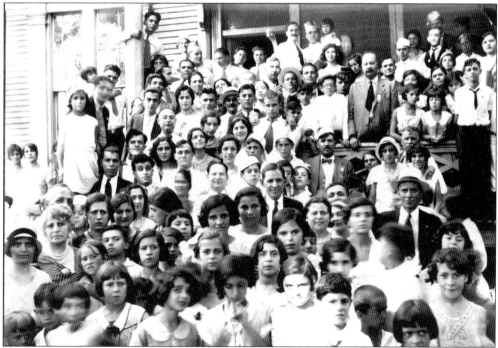

On August 16, 1931, John Booras brought the families of St. Nicholas Church in Manhattan to Staten Island for a picnic as he often did. This picnic was held at DiMaso's on Olympia Boulevard (It is now the Crystal Palace). Angelo Leotta, an Italian from the area, remembers trying to meet those pretty Greek girls. He also remembers their fathers shooing him away. (Courtesy James Kindos.)

The Greeks loved baseball, America's favorite pastime. In fact, three of the Psomas boys played on a semi-professional team. The Staten Island Giants of Travis was part of the Twyford Muche Major League. The Psomas boys received $25 each time they played. George was a pitcher, Gus was a catcher, and Al played short stop. This 1938 team photograph includes, from left to right, (first row) Gus Psomas, George Psomas, Elroy Epple, "Shnipe" Modzelewski, Pat DeCiccio, Horris Laube, and Al Psomas; (second row) unidentified, "Lefty" Santo, Eddy Harai, "Tush" Ontek, Gus Gadzi, Johnny Crabb, and Edward Modzelewski. (Courtesy Bessie Psomas.)

The Greeks also loved the beaches of Staten Island. From left to right, Emanuel Criaris, John Criaris, and Anthony Psomas are on the beach in Huguenot. The huge 1930s Terra Marine Hotel is behind them. When movie stars stayed on the island, they stayed at the Terra Marine Hotel. (Courtesy Elaine Moran.)

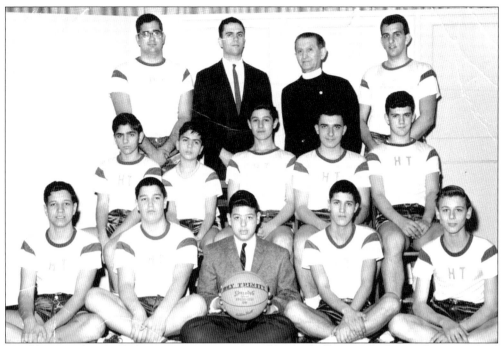

In addition to baseball, the next generation loved basketball so much that Holy Trinity had a basketball team. The 1965 Church Journal had this picture of the team. Shown from left to right are the following: (first row) Peter Kanakaris, Alan Kindos, George Kartalis, Tom Kindos, and Tom Weil; (second row) Tony Proskefalas, George Nichols, Nick Karatalis, Peter Tambakis, and George Avdalas; (third row) John Pavalis, coach John Nichols, Rev. Christos Pappas, and Peter Christofilakes. (Courtesy Peter Christofilakes.)

In 1939–1940, George Katsoris managed a local baseball team in Port Richmond when he was 16 years old. According to a newspaper clip, they planned to play in the Catholic Youth Organization League. George is shown in his uniform, bat in hand. In order to raise funds for the uniforms, he raffled off a toaster and "passed the hat" after each game. (Courtesy George and Evangeline Katsoris.)

Eight

SERVING COUNTRY AND COMMUNITY

The great business of life is to be, to do, to do without, and to depart.
—John Viscount Morley of Blackburn,
Address on Aphorisms, 1887

What does it mean to serve one's country and community? Generally, giving service means to aid or assist someone. Militarily, service is given by aiding and protecting one's country in its endeavors. So, serving the country might be a grander extension of serving the community. However the word is defined, there are many people who have served in a selfless manner. This chapter actually has two parts, those who served in the military and those who served in Staten Island.

Interviews for this book uncovered some interesting facts: some of the early Greek settlers served in the U.S. Army during World War I; quite a few Greek-American World War II veterans are still with us; and as many as five boys from one family were in the armed forces at the same time (World War II). Farmers were exempt, but the Anagnostis boys (George, Gus, Jimmy, Peter, and Chris), all farmers, chose to serve their country. When a sixth son, John, was called into service, the Army felt it was too much of a hardship for the family, so they deferred him. A seventh son, Nick Anagnostis, served during the Korean War.

One of the parishioners, Pfc. Peter Dorgas, an infantryman, was killed in action on May 6, 1945, on Mindanao during World War II. Pfc. Dorgas had previously received the Bronze Star and the Combat Infantryman Badge. There was no photograph available for the book.

Another parishioner, Gust George, was a prisoner of war in Germany. George had kept a journal of his missions. When he was captured, a good friend continued the journal, not knowing whether George would return to claim it. His friend's words on the day George went missing are quite moving. They are included in this chapter. Other Staten Islanders' experiences were less eventful, but everyone served the nation to the best of their ability, whether they served during war or peacetime.

This chapter also reveals the extent to which the Islanders gave service to help the community through their work in hospitals, nursing homes, scouting programs, and educational institutions. A park has been named after the beloved priest, Fr. Spyridon Macris, and a school named after educator, Michael Petrides. Stella Vozeolas and Catherine Cass received the Advance Woman of Achievement Award. These are prominent reminders of the good works by Greek Americans. However, others receive awards of the heart for their good works as they serve the community of Staten Island.

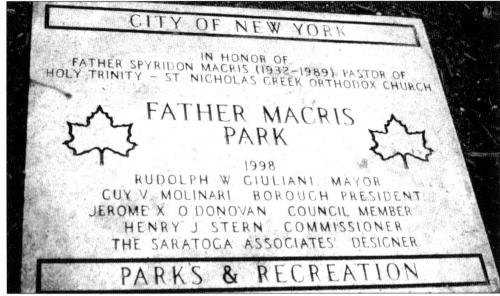

A stone tablet states, "This park in the Graniteville section of Staten Island is named for Reverend Spyridon Macris (1932–1989), late pastor of Holy Trinity-St. Nicholas Greek Orthodox Church in Bulls Head. It is the first park in New York City to bear the name of a Greek Orthodox priest." It goes on to say that he served Staten Island's Greek community for 24 years. He was the first full-time priest sent to the little island. During his years as pastor, the congregation grew tremendously, and his vision for its potential grew with it. This gentle, funny, reverent man was well known to all Staten Islanders. It is fitting that the park which bears his name sits on a spot that was once a Greek farm. (Courtesy Presvytera Anne Macris.)

Stella Vozeolas appears to be saying thank you as she receives the Advance Woman of Achievement Award from Richard Diamond (right), publisher of the *Staten Island Advance*, and editor Brian Laline (left). If so, it is backwards, because Staten Island owes a debt of thanks to her for her 13,000 hours of volunteer service at Eger Nursing Home. Stella, now 102, was still an active volunteer when she received the award at the age of 95 in 1998. She is the same Stella (Kakounis) Vozeolas whose entry into America was highlighted on page 14 of this book. (Courtesy Stella Vozeolas.)

Michael Petrides (whose original Greek name was *Petros* meaning rock) was born and raised in Manhattan. His family spent summers on Staten Island renting Bungalow C at 89 Seaside Boulevard, now Father Capodanno Boulevard, at the cost of $300 a season. The bungalow was just four walls, but it seemed like heaven to Mike and his brother, Constantine. They spent summers playing with the Fossella clan. Later on, they were lifeguards at South Beach and Midland Beach. Mike's adult career was devoted to education, as a teacher, administrator, policy developer and analyst, and public servant. He served on many boards, but is best known for his service to the New York City Board of Education. From left to right, Mayor Rudi Guliani, Constantine Petrides, and Borough president Guy Molinari stand under the sign of the newly dedicated Michael J. Petrides Educational Complex. (Courtesy Constantine Petrides)

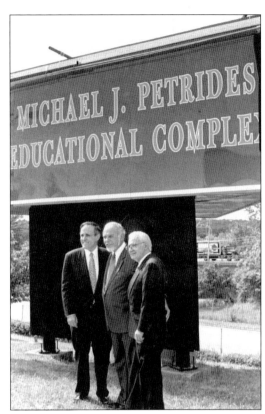

George Garis was the first New Yorker to receive the Dan Beard Lifetime Achievement Award for his work with the Boy Scouts. He is wearing the Silver Beaver, the highest award given by the Boy Scout program. He said that the respect and love from his scouts was his greatest reward. (Courtesy George Garis.)

Costas Thanasoulis served in the U.S. Army in France during World War I. He did not become a farmer right away when he came to America. Instead, he worked in Manhattan as a florist and in Coney Island, Brooklyn, to earn money for his two sisters' dowries. In Greece, his sisters couldn't marry without a dowry, so Costas put his own life on hold until his sisters were settled. Since he was not a farmer, he was eligible for the Army. Later, he became partners with John Bakalis on the John and Gus Farm. (Courtesy Stella Thanasoulis.)

Eftychios Jonas served in France with the 77th Division for one year. He wore a patch on his shoulder signifying he was a member of the New York Statue of Liberty Division. (Courtesy Georgia Jonas.)

Gust George was a technical sergeant radio operator with the 487th Bomb Group. He was shot down on his 18th mission (target Magdeburg) on January 14, 1945, and spent the remainder of the war in prison camps in Wertsburg, Nuremburg, and Mooseburg. This photograph was taken in 1943. (Courtesy Gust George.)

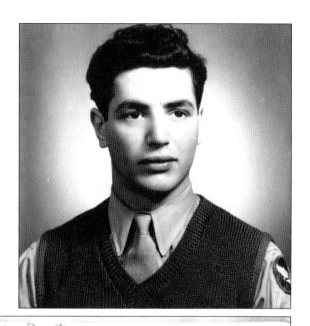

Gust George kept a meticulous journal of his missions and targets. When he was captured by the Germans, his friend wrote these pages in that journal and continued to chronicle his own missions. When Gust returned, he rewrote the 18th mission and completed his journal with information about the food and conditions in German prison camps. (Courtesy Gust George.)

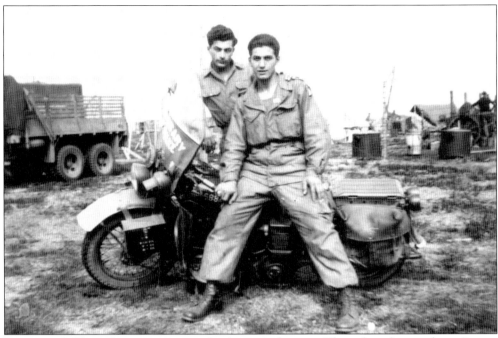

Jimmy and Chris Anagnostis were both in Ardennes. Chris found out where Jimmy was and arranged to meet him overnight before the Battle of the Bulge. Jimmy was a paratrooper, and Chris was a Military Police officer. Jimmy was awarded a Bronze Star and a Purple Heart. (Courtesy John Anagnostis.)

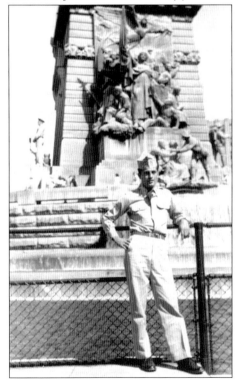

Nicholas B. Anagnostis stands in uniform during his Korean War service. (Courtesy Helen Denis.)

Gus Anagnostis, who reached the rank of lieutenant, was a paratrooper. His record lists "Ardennes-Central Europe, Rhineland, Battle of Bastone, etc." (Courtesy John Anagnostis.)

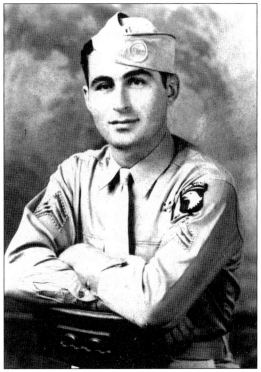

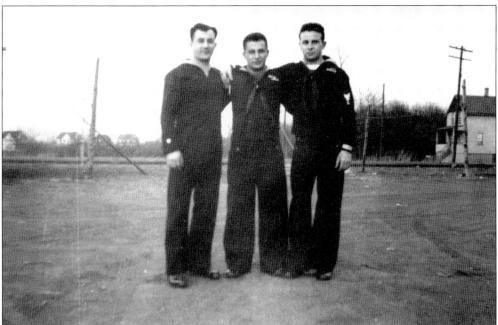

From left to right, Alex, Ody, and George Psomas enlisted in the service shortly after December 7, 1941, Pearl Harbor day. Alex joined the U.S. Coast Guard. Ody and George enlisted in the U.S. Navy. Ody's assignment on the U.S.S. *Merak* took him all over Europe. George was assigned to the U.S.S. *Cole*. When they realized that both ships were in Algeria, they met on the U.S.S. *Cole*. (Courtesy Peter and Georgia Psomas.)

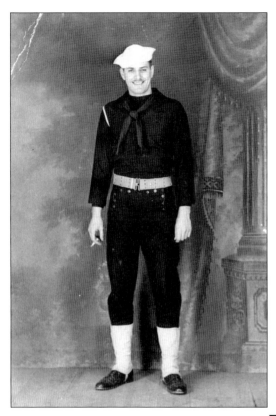

William Cass was in the Navy from February 1943 to October 1945. He served on PT boats and saw action in the following invasions: Anzio, Elba, Southern France, and Borneo. In recognition of his service he received the following campaign ribbons: American Defense, European-African, Philippine Liberation, and Asiatic-Pacific. (Courtesy April Cass.)

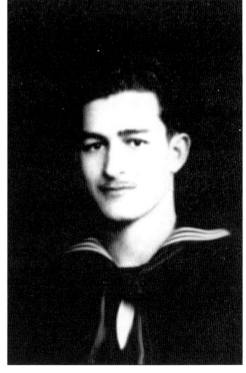

George Garis, pictured here, and his brother, Andrew Garis, were both in the Navy at the same time during World War II. Their mother kept two stars in the window until they returned. George was stationed at a naval supply depot in Mechanicsburg, Pennsylvania. His brother went overseas. (Courtesy George Garis.)

Peter Katsoris and his best friend, Jerome Giovonazzo, were stationed in Liege, Belgium together. In Peter's battalion of 200 men, 100 were from Staten Island. A member of the 563rd AAA AW BN, he saw action in the European Theatre. (Courtesy Peter Katsoris.)

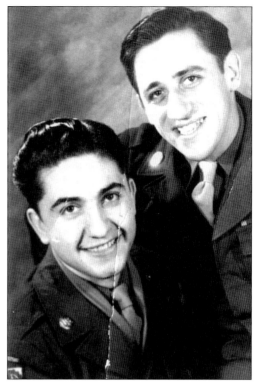

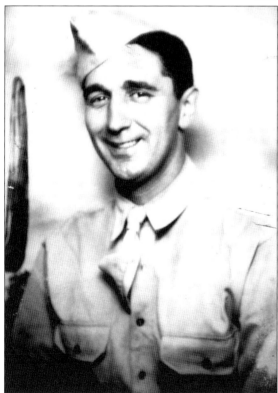

James Kindos was drafted into the Army in November, 1943. He was a member of the Army Infantry 305 A Company 77th Division. He was shipped to Guam. While he was in a foxhole, a tank ran over his foot and wounded him. He spent a year in a hospital in Hawaii where he met a group of Greek-American soldiers. A local Greek restaurant closed every Sunday to all except the Greek-American soldiers for a day of food and dancing. (Courtesy James Kindos.)

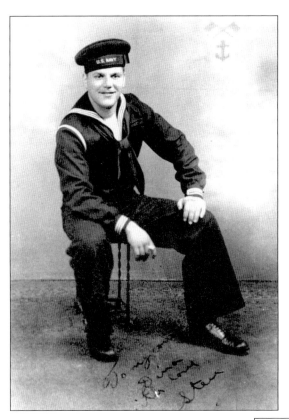

Steve Athanasopoulos (Athens) was a member of the 38th Naval Construction Battalion "Seabees" Company C Platoon No. 2 during World War II. He was sent to the Aleutian Islands to build roadways and airstrips. Then the company was part of the invasion of Tinian Island, where, under enemy harassment, they completed the runway from which the Enola Gay departed for Hiroshima. When the munitions dump on Tinian Island was blown up Steve was knocked from his cot by the blast. (Courtesy Steve Athanasopoulos.)

Costa N. Tesnakis was in the 66th Infantry Division durring World War II. He was on the *Leopoldville* for the first daylight loading after D-Day. When the *Leopoldville* sank, his regiment was sent to St. Nazaire and Lorient. When the war ended, they needed guard dogs for the prisoner camps near Marseille. He volunteered to become a dog trainer, and he trained civilian owned English dogs in Brussels. Each breed was used for a different purpose. Collies were messengers. Poodles were mine dogs. Alsatians were guard dogs. Other breeds were first aid dogs. He was a dog handler at the time of his discharge. (Courtesy Costa N. Tesnakis.)

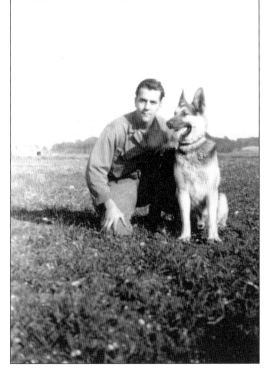

George Corinotis saw a lot of action while he was with the Infantry Division of the Army (European Arena) during World War II where he served 120 straight days of combat. He was wounded when a shell hit his foxhole. On another occasion, his division was in a Catholic church that was being bombed by the Germans. Shells were going off all around. A priest gave him a wooden cross which he held tightly throughout the bombing. The area he was standing in remained free of bombs. He felt that the cross had saved him, and he kept it over his bed for the rest of his life. (Courtesy Helen Corinotis.)

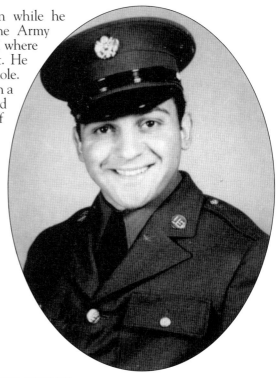

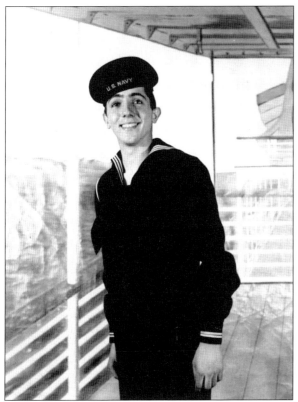

John Stathis was a radio naval intelligence radioman first class aboard the U.S.S. *Pocono*, a radio electronic survey ship. He was in the Navy from 1945 to 1949. (Courtesy Theo Papasavas.)

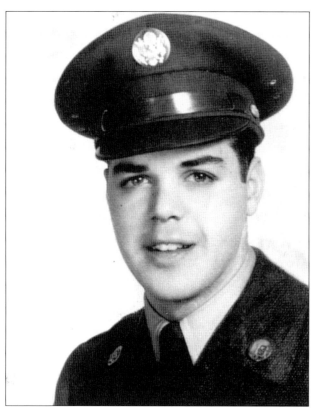

John Kartelias served in the Army during the Korean War at Camp Kilmer and Fort Dix. Since he was an only child whose father had died, he was not sent overseas. He got a compassionate assignment. (Courtesy John Kartelias.)

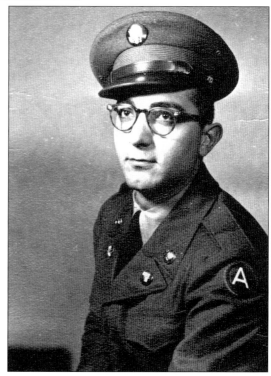

James Stathis was with the 303rd Signal Service Battalion during the Korean War. He was in Sendai, Japan for eight months. His rank was sergeant first class, mess sergeant. (Courtesy Theo Papasvas.)

Alex Itsines served in the Korean War for a year. This picture was taken while he was on a visit home. He is standing in front of the willow trees on his farm. Everyone knew the farm by its willow trees. Arlene Street is behind him. (Courtesy Madeline Johanides.)

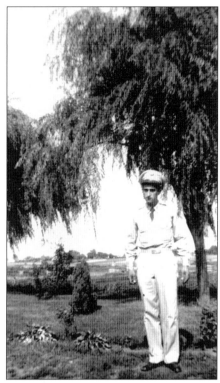

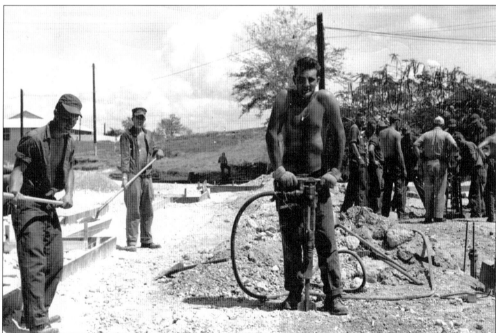

John Charitis (middle of photograph) served in the U.S. Navy "Seabees" Mobile Construction Battalion 8 Company C from 1959 to 1962. He was stationed in Guantanamo Bay, Cuba, during the Bay of Pigs Invasion and in Bermuda. This photograph shows the start of construction for base housing in Guantanamo Bay, Cuba. (Courtesy John Charitis.)

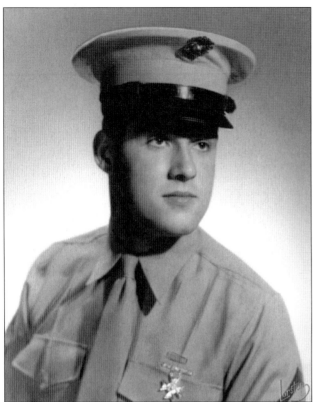

Nick Papas volunteered for the Marine Corps and served from 1961 to 1965 in the 8th Engineer Battalion. He served in DaNang and earned the rank of lance corporal. (Courtesy Elizabeth Papas.)

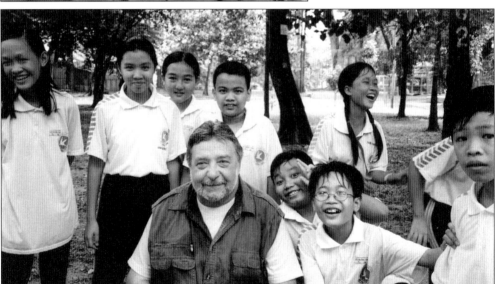

George Athas was a radio operator, a member of Advisory Team 86 when he was in Vietnam from December 1966 through December 1967. He was awarded the Vietnamese Cross of Gallantry and earned the nickname "the Judge." He has written a blunt book about his experiences in Vietnam titled *On the River*. He has since returned to Vietnam to help rebuild the roof of an orphanage. It was the same roof he had helped to build in 1967. (Courtesy George Athas.)

After graduating from the United States Naval Academy in 1990, Anthony Kyvelos served in the Navy for six years. He had two tours of duty, the first aboard the *Jack Daniels*, and the second aboard the U.S.S. *Wasp*. His final rank was lieutenant. (Courtesy Dan Kyvelos.)

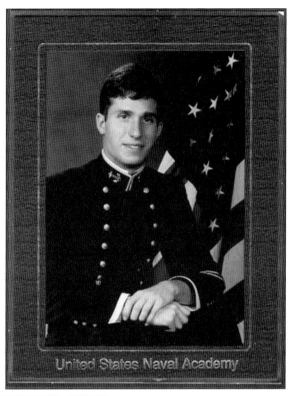

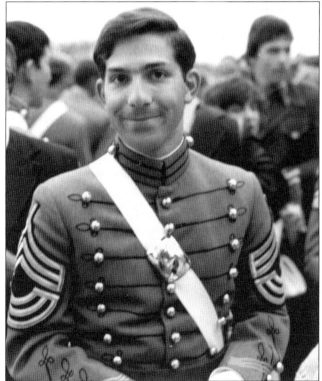

Arthur Veros graduated from West Point in May of 1978. He was commissioned second lieutenant. He served with the 82nd Airborne and the 101st Airborne and left the army after 11 years with the rank of captain. (Courtesy Mary Veros.)

ACKNOWLEDGMENTS

I am not a native Staten Islander. I don't speak more than a few words of Greek, and I have never been to Greece. Yet I felt compelled to write this book about Staten Island's Greek people and their impact. Why? It took me some time to sort it out, but I realized that I had been preparing for it from childhood. When I was growing up in the Bronx, my father was a professional photographer. He photographed everyone and everything. The photographic memories that my aunts, uncles, and cousins possess are from Albert Cambetes's camera, because he shared his pictures with them all. When I grew up, I was given a typed copy of *Passions at Large*, a small, unpublished book my maternal grandmother, Victoria Vahanian, had written about her experiences as an Armenian in Iran. It documented the Armenian genocide that took place between 1917 and 1920 and her struggle to keep her remaining family members together. Thus, my family history was preserved through photographs and the written word.

The third element occurred many years later when I took a course at the College of Staten Island entitled, the History of Staten Island with professor Howard Weiner, and wrote a paper about the Greek Farmers of Staten Island. At the time I jokingly said I would turn that paper into a book someday. How to do it? In 2004, Arcadia published Jenny Tango's book, *The Jewish Community of Staten Island*. The answer to my question was there in the pictorial histories Arcadia is famous for. I could combine photographs and words to tell about Staten Island's Greek Community.

I am indebted to many people for their help with this book. Rev. Nicholas Petropoulakos encouraged me from the start and gave me access to all of the church's documents and photographs. He answered my questions about religious aspects of the book. Dr. Nicholas Itsines wrote a history of the first 50 years of the church in 1977. This document is a wonderful source. Without it we would have to rely on the fading recollections of our elders whose children look at family albums and do not know who or what they see.

The parishioners of Holy Trinity-St. Nicholas Greek Orthodox Church have been helpful and supportive during my research. They have entrusted me with their histories, their photographs, and stories. Special thanks must be given to a few individuals. George and Evangeline Katsoris met with me often to pore over the albums and documents they had compiled. George's memory and Van's scrapbooks are amazing. Olympia and Gus Skunakis, Mary and Louis Chrampanis, and Mary Veros, were available at any hour when I would call and ask for information about a particular image or event. Carlotta De Fillo, research assistant at the Staten Island Historical Society, and lover of classical Greek language and architecture, helped me to find wonderful historical photographs. George D. Tselos and Jeffrey S. Dosik, of the Ellis Island Library were a source of information about Ellis Island procedures for the immigrants arriving here.

The *Staten Island Advance* has chronicled the history of the Greeks, the church, and the festivals. I am grateful to Steve Zaffarano, *Staten Island Advance* photo editor, to Maureen Donnelly, librarian, and to Anthony DePrimo of the imaging department for their help in retrieving photographs published long ago. Gregory Grisha Ressetar, who photographed that famous image of *St. Nicholas Church in the shadow of the World Trade Center*, instantly gave permission to include it. Joanne Nuzzo, director of special events for the borough president, was helpful in obtaining information about awards and ceremonies that have taken place on Staten Island.

The staff at Arcadia Publishing has been most patient and helpful while I tried to figure out how to put a book together. Speaking of patience, my husband, John Charitis, should be given an award for his patience and understanding during this whole process. He would look at a group of images and instantly see which one best reflected the text I needed to include. He has encouraged me from the first tentative thought I had to do this book. He is hopeful that we will see our dining room table again soon, free of the hundreds of images that have adorned it these past few months.